NUDE PHOTOGRAPHY NOTEBOOK

A notebook is the source of my creativity —
a place to find inspiration and develop ideas.
Within its pages I also explore my photography
and refine my technique.

A.J

First published in 2006 by Argentum,
an imprint of Aurum Press,
25 Bedford Avenue,
London WC1B 3AT

A slip-cased, signed and numbered 'Limited Edition
Book', and the 'Collector's Limited Edition Book' with an
original print, are available from Self Publish Solutions.
www.selfpublishsolutions.com

A catalogue record for this book is available from
the British Library.

ISBN 1 902538 43 9

10 9 8 7 6 5 4 3 2 1
2010 2009 2008 2007 2006

Created and designed by Eddie Ephraums,
Self Publish Solutions
www.selfpublishsolutions.com

Printed by Die Keure, Belgium

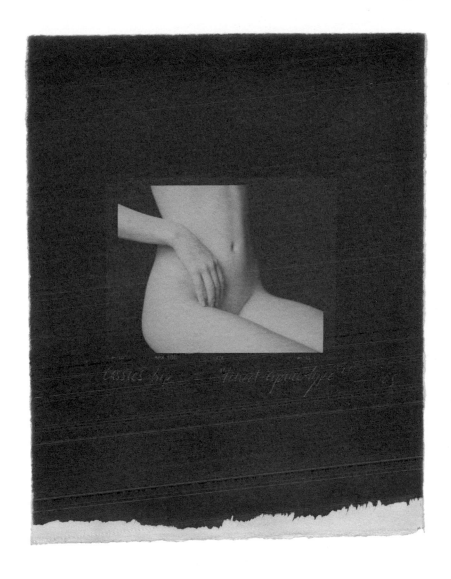

NUDE PHOTOGRAPHY NOTEBOOK

Finding inspiration. The work of Allan Jenkins by Eddie Ephraums

ARGENTUM

CONTENTS

Some eight years after the idea of collaborating on a project was first mentioned, Allan and I happened to occupy adjoining studios. Finding inspiration in each other's work... the Notebook began.

A NOTEBOOK…

…must write it all down, where is my notebook? If I don't sketch the idea visually I might forget it! Quick, store it. Bottle it! I need to capture these thoughts, this feeling, this freedom… A.J

An invitation to look within
The Notebook aims to get inside the process of making fine-art photographs, exploring the essence of inspiration.

A notebook follows no rules. It can be whatever we want: self-expressed, free from constraint and with no commercial need to satisfy. Not an indulgence, but an opportunity to explore, reveal and bring to life the creativity that lies within all of us. What artist – *what photographer* – would be without one?

Notebooks are rarely published. Yet, go to any exhibition where the artist's notebooks are also on show and visitors will congregate there, looking for clues, hoping to connect with the very essence of the artist's creativity (as the artist in all of us wants to). This raw source may sometimes be inadvertently concealed in a more conventional, planned and edited book or curated exhibition.

The *Nude Photography Notebook* aims to be both a notebook (an intimate source) and a book (something shared), that reaches out to that wider audience – hoping to inspire and stimulate thought. By opening his personal notebooks and studio to the scrutiny of my camera and now the enquiring eyes of this published book, Allan Jenkins holds up a mirror to his work. He and I hope it may inspire others to do the same, thus helping to reveal more of what individual creativity is about.

Allan is equally well known for his still-life, portrait and travel photography as he is for his nudes. Because this book focuses on his photography of the female form, it does not exclude lovers of, say, landscape or reportage (like myself) from sharing what the Notebook is about – *Finding Inspiration*.

It is Allan's way of 'Being' that inspires subjects to sit for him and which also initiated the making of this book. He recalls our very first meeting some eight years ago, when (in a very understated way) he suggested that one day we make a book together. What are such utterances other than verbal jottings and one's subconscious *being* unselfconscious, making notebook-like declarations of intent? Now, eight years on, as I write this, I am close to filling up the pages of that very book.

Linear path or circular journey?
Traditional books on the process of photography tend to follow a logical sequence: subject, camerawork, exposure, processing and printing. In *Nude Photography Notebook*, the aim is to follow a less prescriptive route that advocates creative photography as an on-going journey – one of continual departure and arrival.

Capturing the Image.

Shoot — lens — body's in lens — slow music

① abstract body shots.

↓

Sketches —

↓

② more body shots.

↓

darkroom and studio

↓

③ more body shots

↓

prints being printed ⟨ coatins
washing
pressing.
spotting.

↓

④ photograph to present

↓

Subject and process joined round door.

↓

result — message. memory. story.

Finding Inspiration

We all have different photographic styles, yet the goal is shared: to find inspiration and to develop our own unique way of working.

Allan works with large format and, to date, I've worked mainly with 35mm, in black and white. In further contrast, this is the first book for which I've photographed in colour: experimenting with a little, hand-held digital camera and Photoshop – a very different experience and still rather new. My thinking was that colour imagery would contrast well with Allan's grain-free, 'real' photography. For a book, maintaining variety is as important a factor in retaining a viewer's interest as the images themselves.

Taking pictures in Allan's studio has been very different to making my more usual black and white landscapes. There were no shadows to chase and, though the studio is artificially lit, there was very little light to play with. It's an atmospheric place and flash was not an option; I wanted my pictures to be natural – to appear effortless. In the context of the Notebook, I saw the need to make them, in a sense, invisible – to act as the 'glue' that held the overall picture of the book together. I wouldn't be putting myself down if I said that the function of some of them was to be the wallpaper on which Allan's images were to hang. (A challenge to any photographer more used to trying to create images that speak for themselves, rather than those that quietly help to reveal hidden truths). After all, the Notebook does use Allan as the subject for exploring something of the nature of creativity, through its chapters on Inspiration, Ideas, Photographs and Technique.

Working within the physical confines of a studio environment was surprisingly liberating. This sense of freedom encouraged me to work spontaneously, without either a tripod or hesitation, framing images instinctively. Hence my choice of a simple digital camera. The result is that many of my one-to-two second exposure pictures are somewhat unsharp and, when enlarged, these tiny jpegs also exhibit digital noise.

Photographic convention considers both of these attributes far from ideal. But as there are no rules for illustrating a notebook, why should the Notebook conform?

Eddie Ephraums
2006

Beyond camera technique
Allan's approach is deliberately simple. Mostly he works with an old, shutterless 10x8, removing the lens cap to make the exposure, and counting for a few seconds. His focus – and that of the Notebook – is on creative expression, as seen through his toned cyanotype prints.

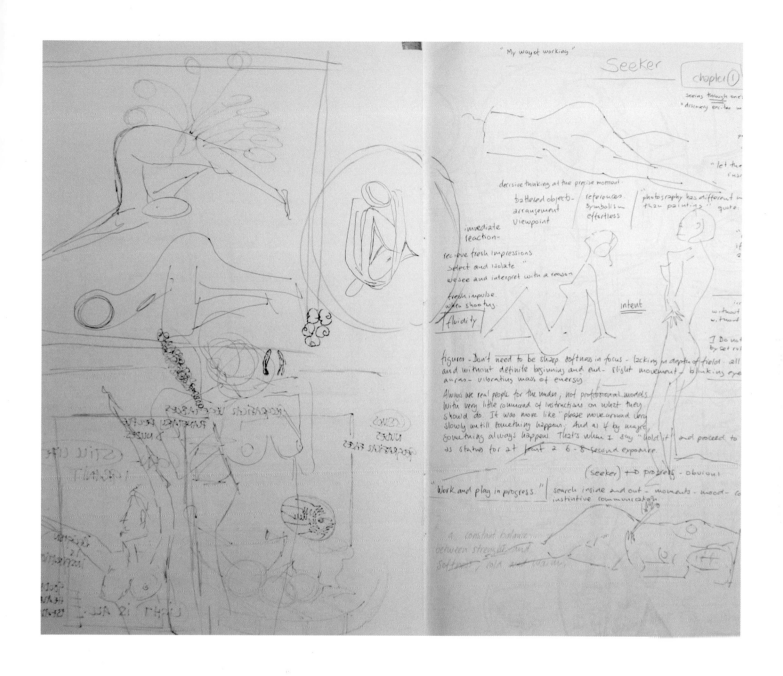

I find myself working towards expressing an overall sentiment, often without a pre-determined outcome, just a few guidelines and a series of unspoken rules.

1

Inspiration

I'm inspired by the way light makes objects look magical and ethereal.

...ke almonds cooling and concealing the...

Eyelids, lips, hand...

...ck velvety shadows that divide the shape with its...

The hand...

...Shadow, underneath...

...Fresh and...
...ncomplicated and...
...how we are...
...xpression are...
...he obvious...
...tualities within...
Neck, wrists, ankles and...
A simultaneous action that creates changem...

ORIGINS AND INFLUENCES

Inspiration is photography's driving force – the source that motivated us to take our first ever photograph. It has lead to that never-to-be-forgotten thrill of watching the image appear in the developer and now to the buzz of seeing it in an instant, on an LCD screen. How connected do we remain to that influence – our original desire to create? Time, perhaps, to re-connect with our origins and to re-discover our photographic influences.

Keeping inspiration alive
Reference points remind us of who we are and what our work is about. Allan has an ever-growing collage of prints above his light-table. Above that is a bookcase, to which are pinned numerous cards. An equally powerful reminder might be 'Variety', the label on a negative storage box.

SA + ULRIKA

ELISABETH

LISON

SONIA

NNA

NICOLA

SONIA

NGELS WITH WINGS

THERESE

NNA + LENKA

SIAN

TILLY BLA

RENEE

DANIEL SF

MARTA

LONDON PR

MIRELLA

LEXY

SYBLL

SUSCHI

EMMA BA

ZO

STY LITTLE

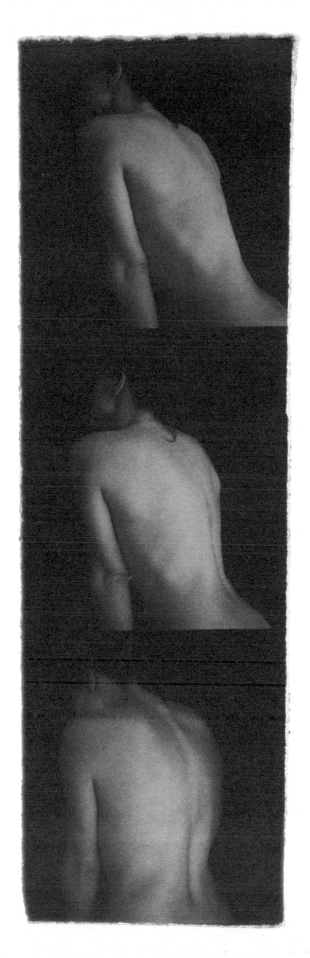

Our natural urge to express inner thoughts and instinctive ideas is constantly influenced by our surroundings and experiences, and is activated by our desire to communicate.

The desire for self-expression

'*Work and play in progress.*' These words could be the dictum of any artist. They describe that wonderful unselfconscious connection with one's creativity: those times we create without thinking, totally satisfied and utterly absorbed in a state of flow, with originality, rather than habit, guiding our efforts.

Play cultivates simplicity and encourages us to let go of the desire to control – an obvious barrier to getting the best out of a subject. It breaks the spell of overly conscious action and gives access to a deeper, more natural, state of perception in which our treatment of the subject also becomes a clear reflection, and therefore expression, of ourself.

Friends and acquaintances
5x4 negatives housed in vintage watch-part boxes, found outside an old repair shop.

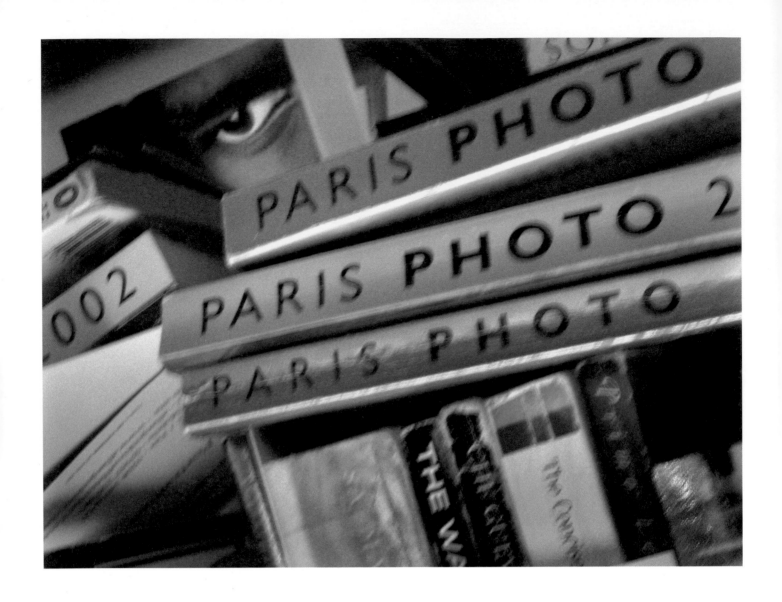

Accumulate, dissect, repeat and innovate.

Behind the scenes
Photographic catalogues, like these from *Paris Photo* annual photography fair,
can be a valuable source of inspiration, and provide information about the
world of photography: who's doing what, where, how and why?

Once inspired, the urgency to capture the moment is apparent. We want to preserve, re-interpret, build on and manipulate our work through the images we make. For this, I have chosen photography as my medium and notebooks as a way of recording the essence of these inspired moments - for the purpose of coming back and reconnecting with them later.

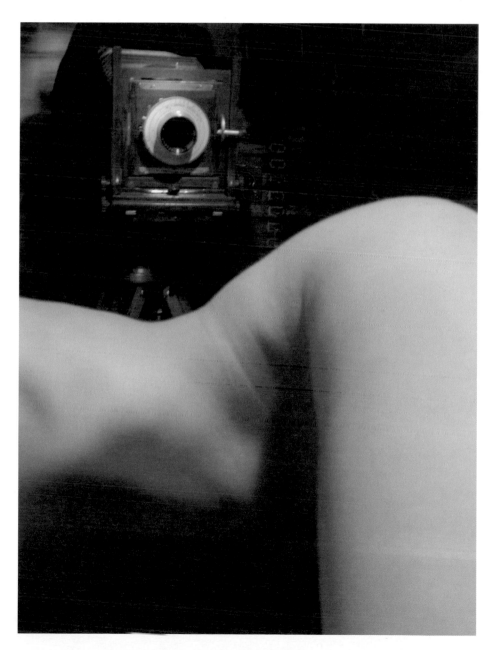

Behind the camera
Most of Allan's prints reproduced in the Notebook have been shot on either 10x8 or 5x4 film.

Although very ...
with ...
should ...
slowly ...
something ...
as status

"Work and

play in progress !!

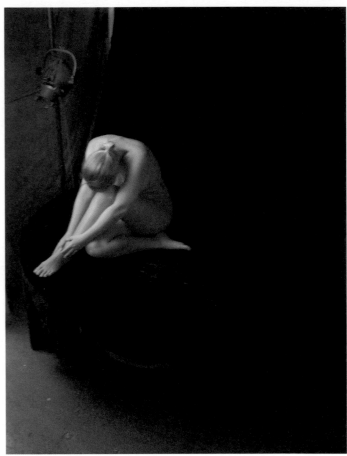

Taking influence from other artists

Imitation, emulation… aspiration.
We are told that nothing is original, everything has been done before. Allan's nude sketch, above, could have been inspired by a Weston photograph, but does this matter? What interests us is the way ideas are used. If we go no further than imitation, it is useful only if the process teaches us something about the nature of creativity. Emulation, too, only serves a purpose if it gives us a sense or a taste of what it's like to create something. Taking an idea 'beyond' and making it our own is authorship and constitutes artistic endeavour.

Who hasn't been inspired by the greats, like Weston's *Charis* or Brandt's Belgravia nudes? And how about Bonnard's famous *Nude in a Bathtub* and the inventive way the painter lit his subject with light reflected off a collage of multi-coloured sweet wrappers?

There is something about artists who are happy to break with convention and find their own unique way of working. Today, people criticise digital photography for its ability to manipulate. What about the unnatural colour of *Nude in a Bathtub*, or the way its elderly subject was doctored and transformed back into the artist's once young muse?

As artists, we are often inspired by others, including the everyday people we meet and the conversations we have. We also take influence freely from what is around us: the books on our shelves, postcards stuck above our workstation, the ever changing views of nature – even easily overlooked items, like disposable wrapping.

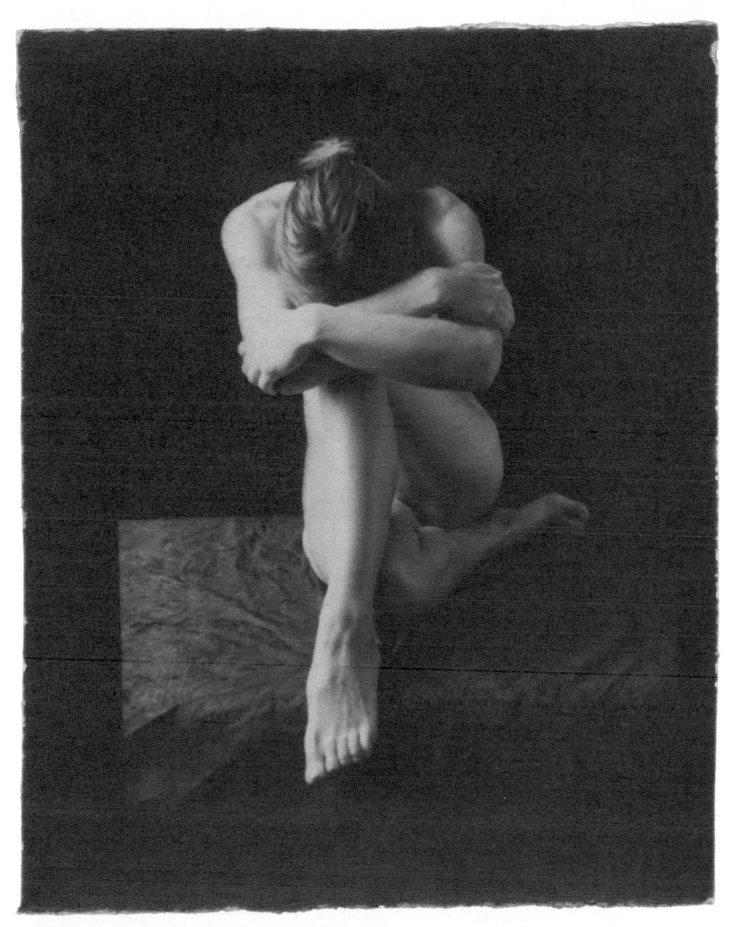

AUG 8 1932

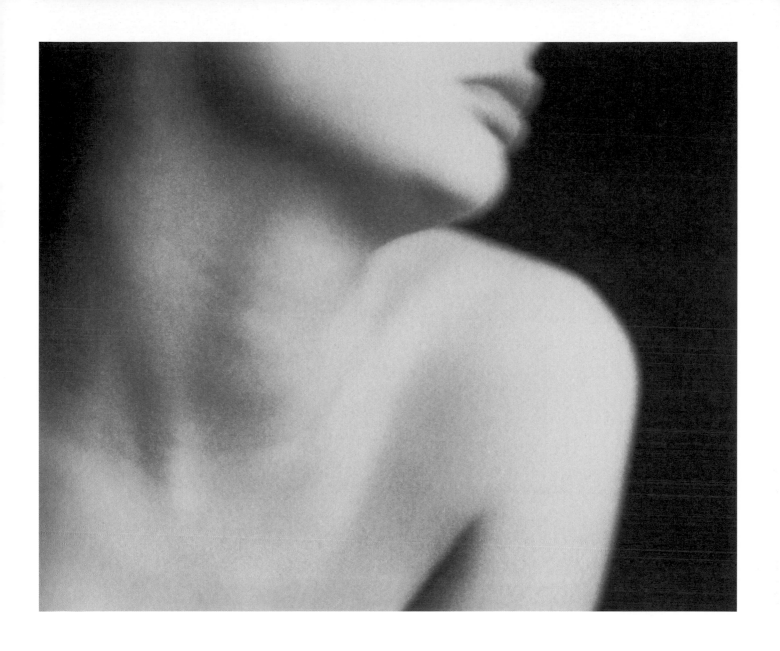

A facial expression can reveal an excess of identity.

Early influences

A drawing by Victor Keyes, the grandfather of an art college friend of Allan's, dated August 8th 1932 – and surely worth more than a 2+. The influence of this image: the body as sculpture and the simple use of directional lighting, together with bold cropping, is evident in Allan's style of work, as in *Valeria's Lips* above.

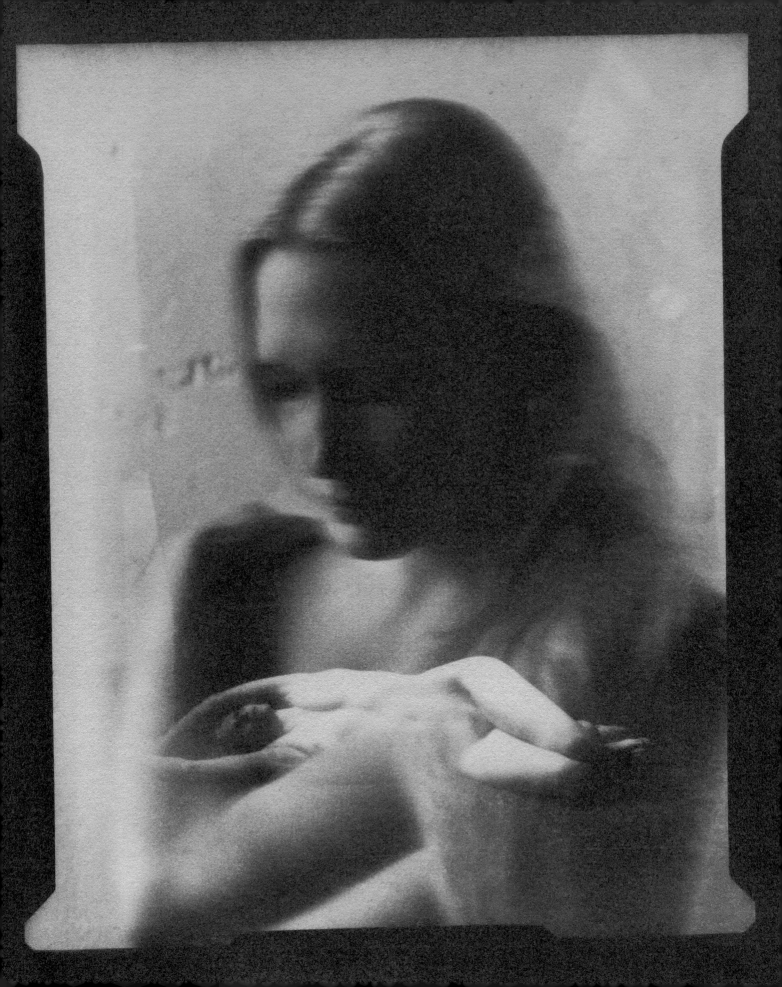

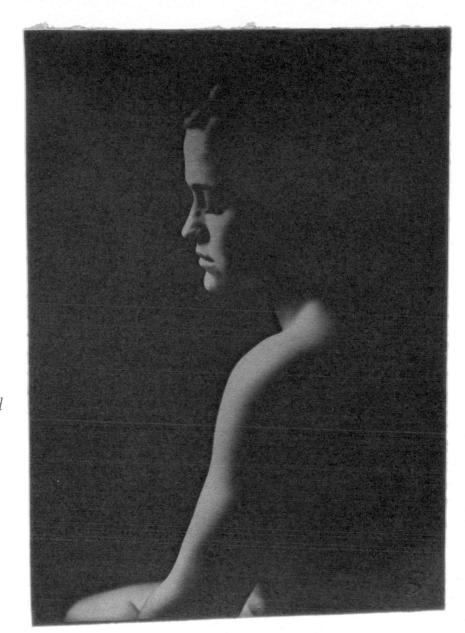

Attracted to certain styles, moods, messages, we re-interpret and take note. From this accumulation appear our own discoveries and creations that have foundation in others' and have been encouraged by that initial source of inspiration.

We accumulate, dissect, repeat and re-invent…absorbing influences is a way of advancing our thoughts and following on from where others left off. Art is an open mode of expression, where everything can contribute and all influences are valid. Looking back to look forward, a starting point from which to evolve and develop one's own personal style.

Theme and process joining forces to strengthen the final result.

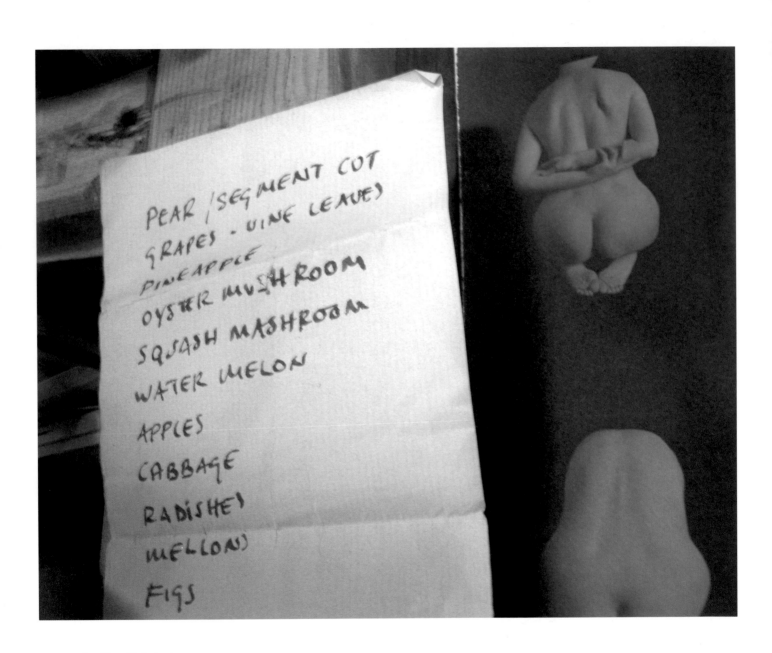

Art imitating life…life imitating art
A beautiful, pear-shaped figure, part of a contact
strip of experimental shapes and poses, next to a
list of mixed fruit and vegetables – to be purchased,
perhaps, for one of Allan's still-life shoots, or written
to inspire further ideas for nude studies?

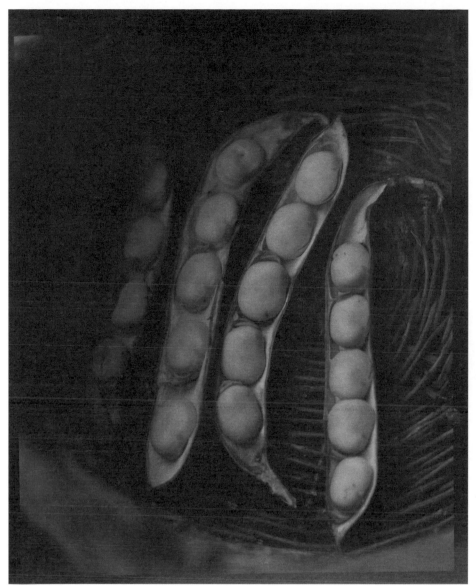

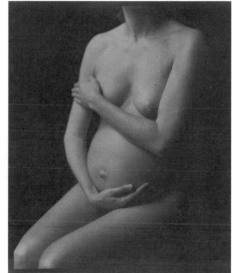

Life and nature as a source of inspiration

A search for perfection can easily be confused with a need for simplicity. The inspiration we look for may be all around us in our daily lives, our interactions with people and in our everyday environment. The magic of photography often lies in capturing the 'obvious' and making it unique, simply expressing the nature of nature, exploring our relationship with it to reveal its special shape and form. It is witnessing life in the proverbial grain of sand...the ordinary revealing the sublime.

Working with an overly familiar subject often seems hard and uninspiring. The temptation will always be to look for the new, to go further afield and to seek afresh. But, with time, even the new will begin to look routine and we may find ourselves repeating the same old message. Perhaps we sometimes make pictures for the thrill of being *there*, in that new place, rather than being connected *with* it.

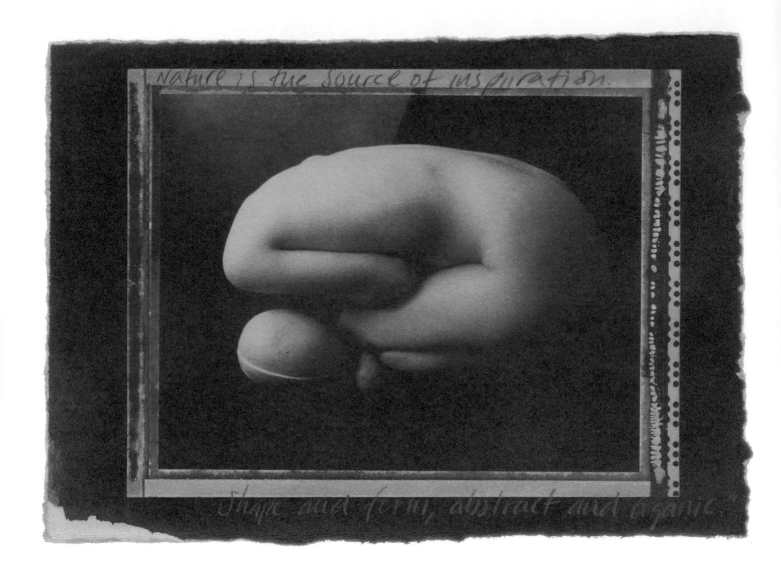

Nature is the source of inspiration.

Shape and form, abstract and organic.

When we look at an artist's magnum opus we're seeing where they have arrived at, not where they finished. Perhaps the role of another artist is to take their discoveries further, and to go beyond. Almost like scientists working towards a common goal.

Sketch from a notebook
Allan often revisits an idea after a shoot and might make sketches of the image, in this instance to refine shape and form. Persistence in finding the right shape has been influenced by his painting practice at art school.

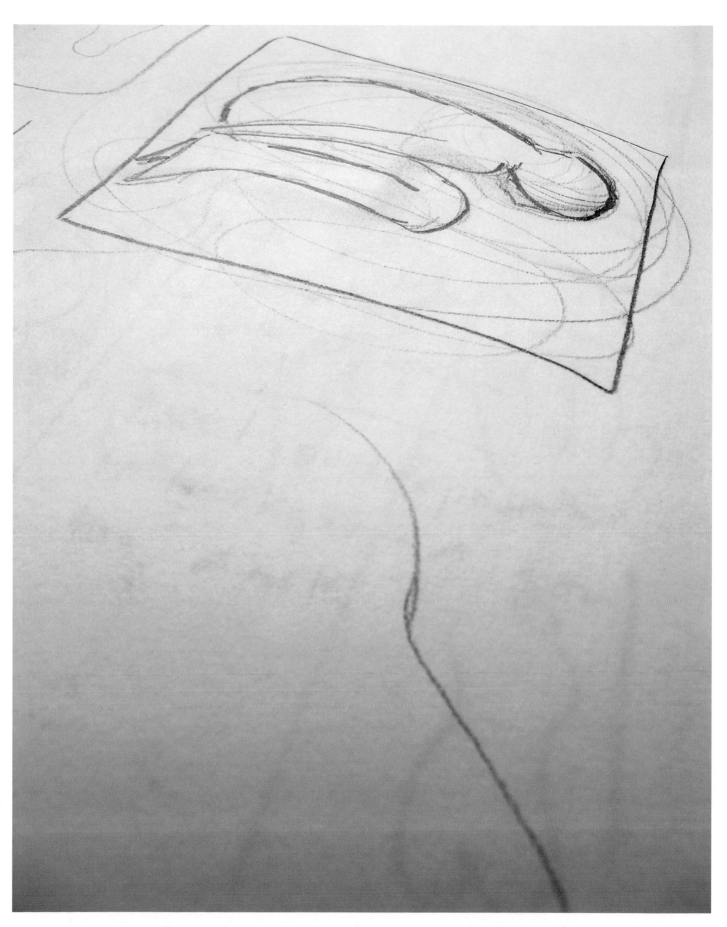

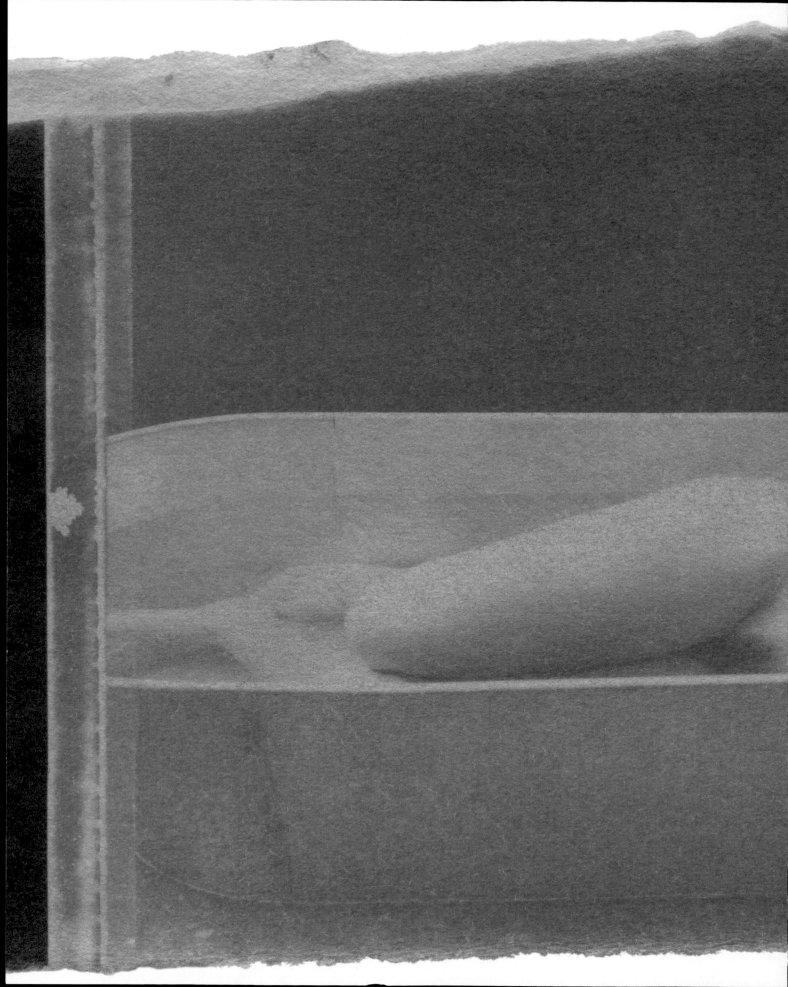

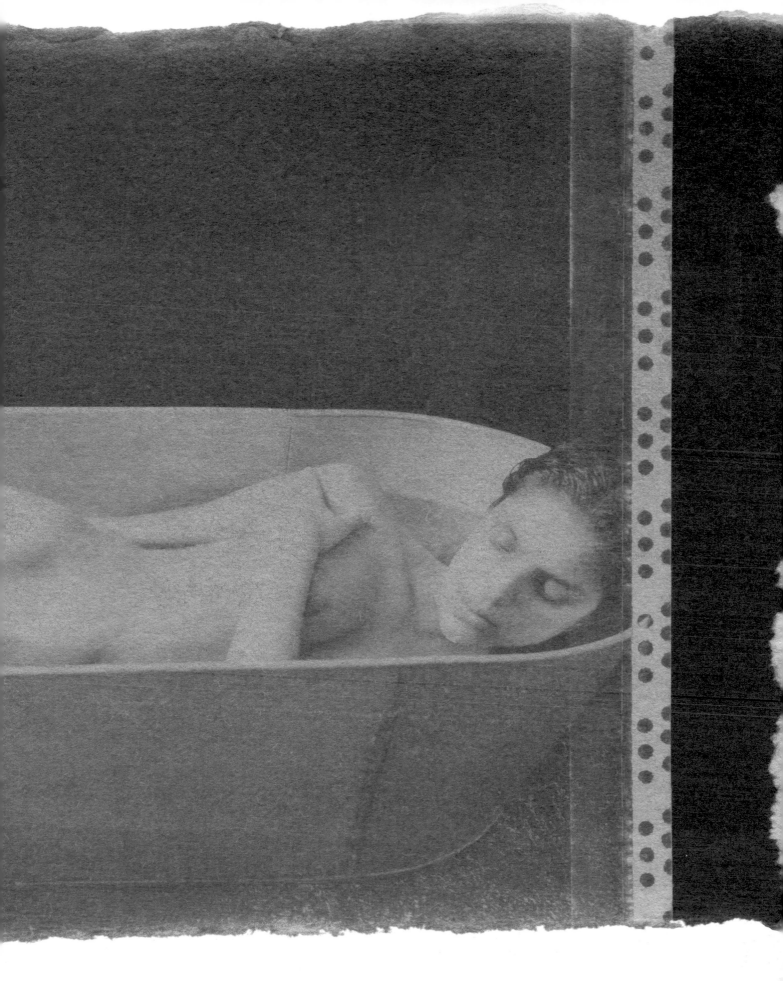

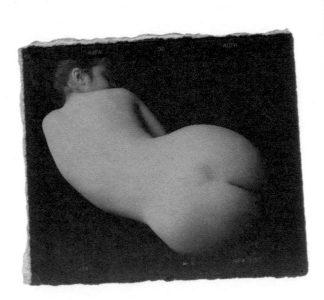

Balthus, was a source of inspiration for this series of poses,
Annika told me he was her favourite painter.

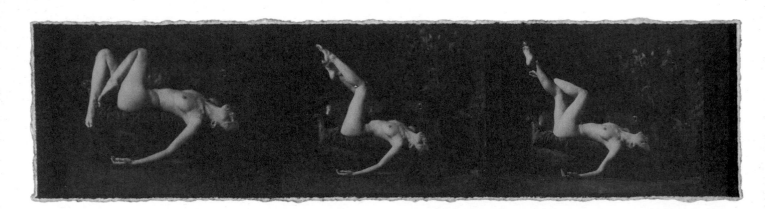

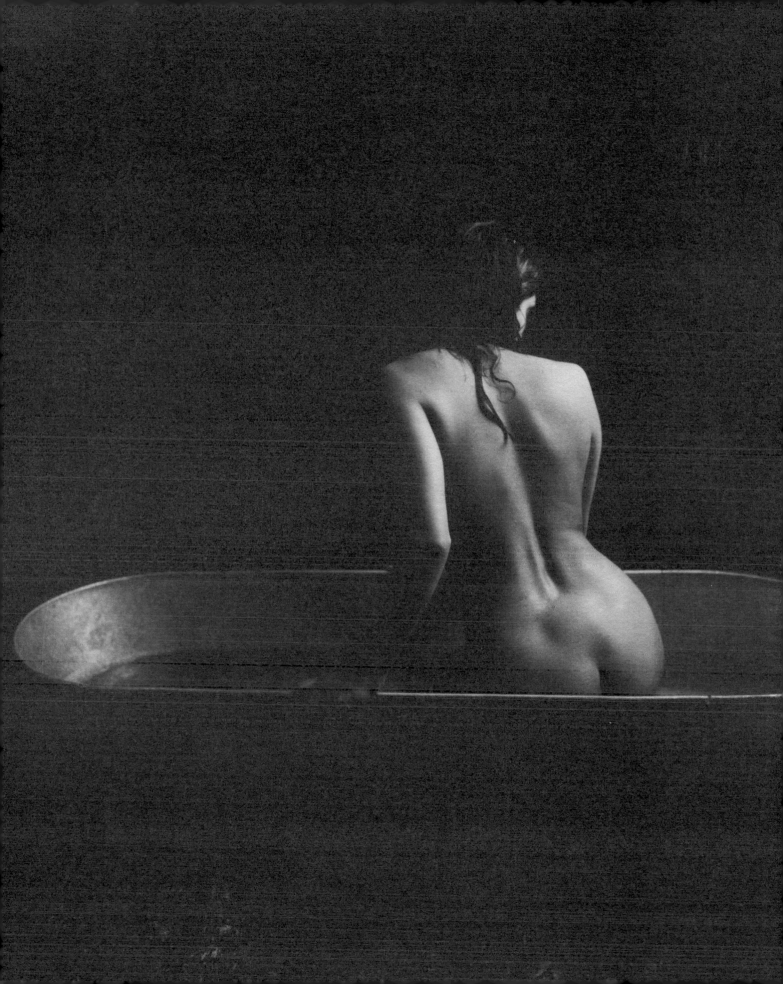

ideas

Usually the subject matter gives us the best idea of how to make the picture.

Lips as sharp and accurate, as if painted
sculpted by lines and sharpness of curve.

Landscaped hills that create the background of
the figure, made by the figure itself.

INTUITION AND INTENT

Developing our creative ideas requires a real understanding of who we are and what our personal goals might be. But how do we access such intuition and intent, so they can be made clearer, for us to act on them to foster their growth? There are many processes that could help, the most obvious is to continually make and edit photographs. Another method may lie in the manifest power of a notebook, whose pages reflect and reveal afresh.

Keeping inspiration alive
A picture of *Anna* on Allan's website. The web is a great place for the curious: *'I might type in Fine Art Nude Photography and see what comes up.'*

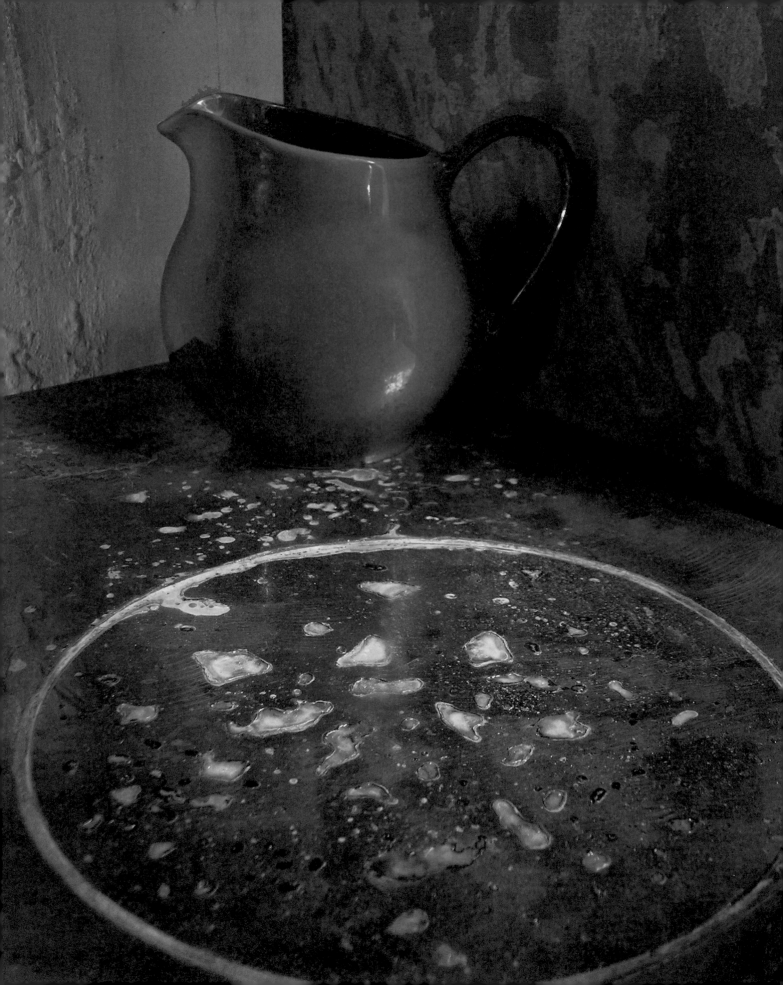

Small details leading us somewhere we are yet to see.

The creative environment

A studio provides the perfect environment in which to explore. It is a place for the artist to express what lies within. The size of the space is immaterial; it could be as small as a day-lit window ledge or as large as a landscape, so long as it's somewhere to work and play.

Our chosen creative environment provides an infinitesimal and exciting source of subject matter. But it is what photographers reveal of themselves, through the subjects they photograph, that separates great work from the average. This is an ongoing process.

We may perfect and refine our technique, but with every creative step forward comes the desire to reach new levels of discovery. Satisfaction with one's work comes not through the search for that perfect subject matter, or from other desires, such as for public recognition, but through quiet determination. A commitment to practising the art of revelation is the photographer's best tool and the creative environment the perfect place for it.

The place we work in is our notebook
Everything in it contains potential of some sort: something as simple as a rust circle, or as innocent as an apple, might be the inspiration for an idea.

The concept of continuity – gathering moments and details, which come to life through time.

A way of seeing

Sometimes we see it all in an instant and no tangle of thoughts can hold back our ideas. Other times it takes hard work and we move slowly forwards in the dark, somehow feeling our way towards making an image.

Seeing comes in many other, often subtly different, forms. We may notice, glimpse, catch sight of, distinguish, make out or even detect. Then we might perceive, behold, understand, grasp, comprehend and take-in, before we go on to realise, appreciate, envisage and, finally, visualise a picture. Whatever the approach, seeing equates to putting our mark on the process of picturing – all part of the practice of awareness, realisation and response that is photography.

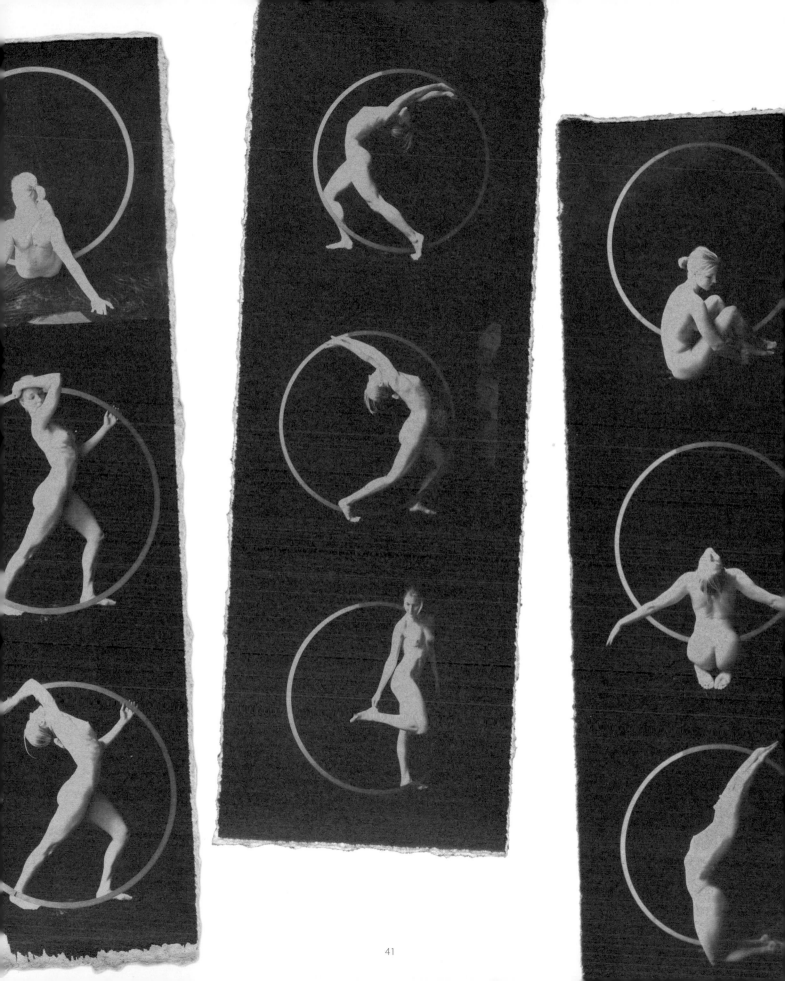

...a chronological order to filing my images. A discipline that helps me understand where I've come from and where I am heading with my work.

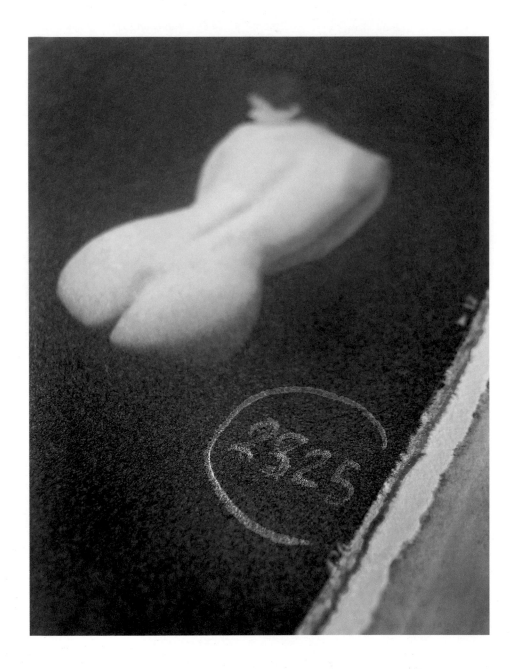

2325

A contact print of *Valeria's back* in one of Allan's notebooks. (Its reference number enables him to revisit and review his work, as well as record details of limited edition sales).

23488

One half of a salvaged wooden cable-holder turrned into a table, used as the stage for nude shoots and for laying out work to view. The other half was made into the door of the darkroom.

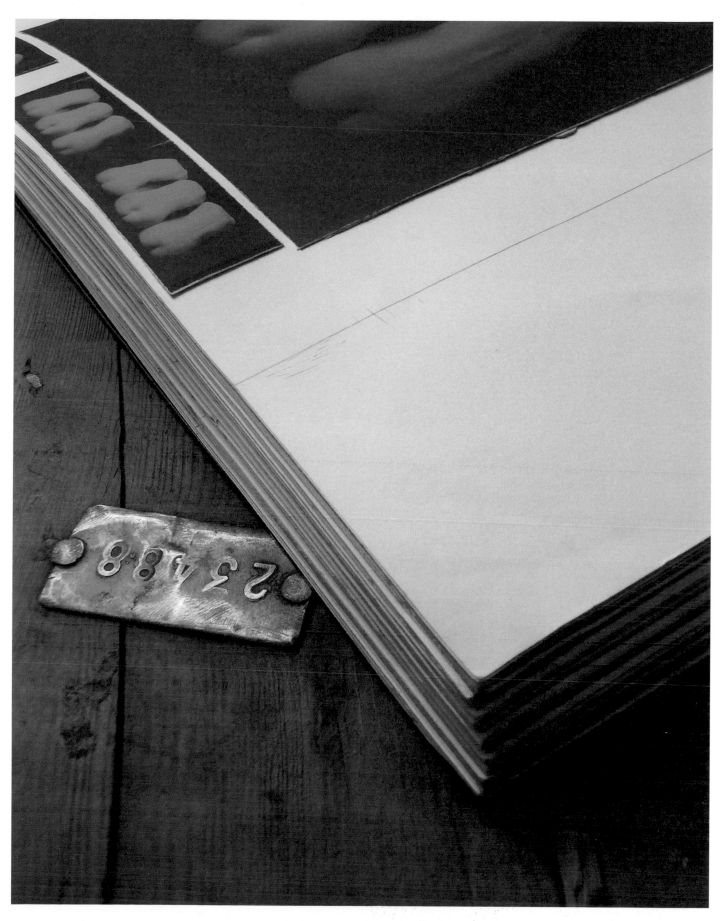

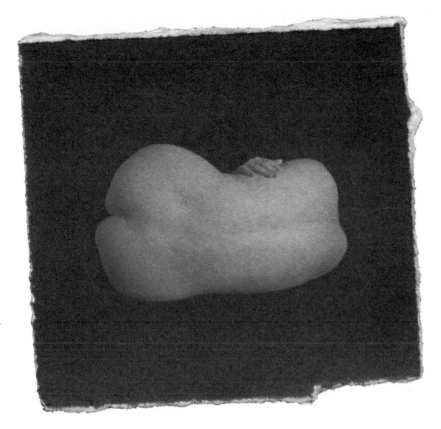

Sketches are a good way of showing the model the intention for a shoot - to enable them to visualise what the idea is and giving them something to work towards. Of course, any idea is there to be adapted and the shoot may go in another direction.

Communicating intent

It could be said that the art of photography is in the editing, recognising what works, and why, and presenting it accordingly – more a process of contextualisation and less a matter of taking more images in the hope that something better will be achieved.

Some pictures work best on a gallery wall, others in the pages of a notebook. The remainder may sit rejected in boxes, waiting to be (re)discovered. The passage of time always brings with it a fresh eye. No picture is a waste and many benefit from being seen in a new light, sometimes years later.

The intention of a picture may not be to serve our immediate ambition. Those that immediately achieve what we want, may appear to work, but they may not take us anywhere new. Often it is failure, or unforeseen success, that drives creativity. We need to exercise the confidence to feel free to fail and to be open enough to acknowledge that sometimes our images may unexpectedly speak more powerfully than we ever can.

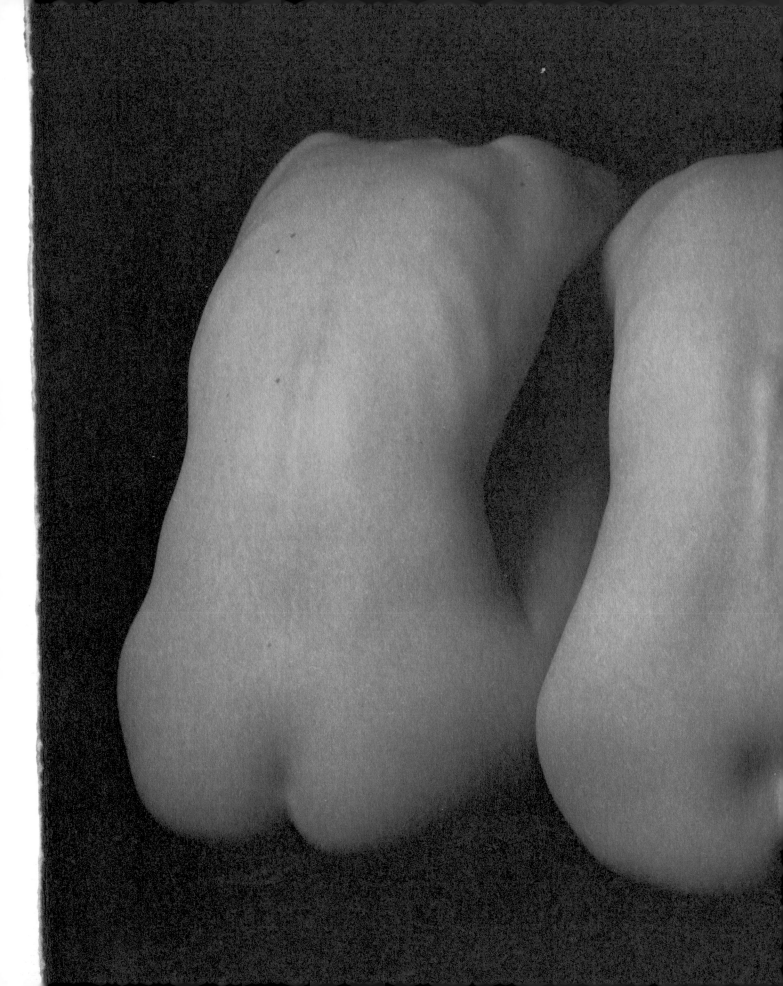

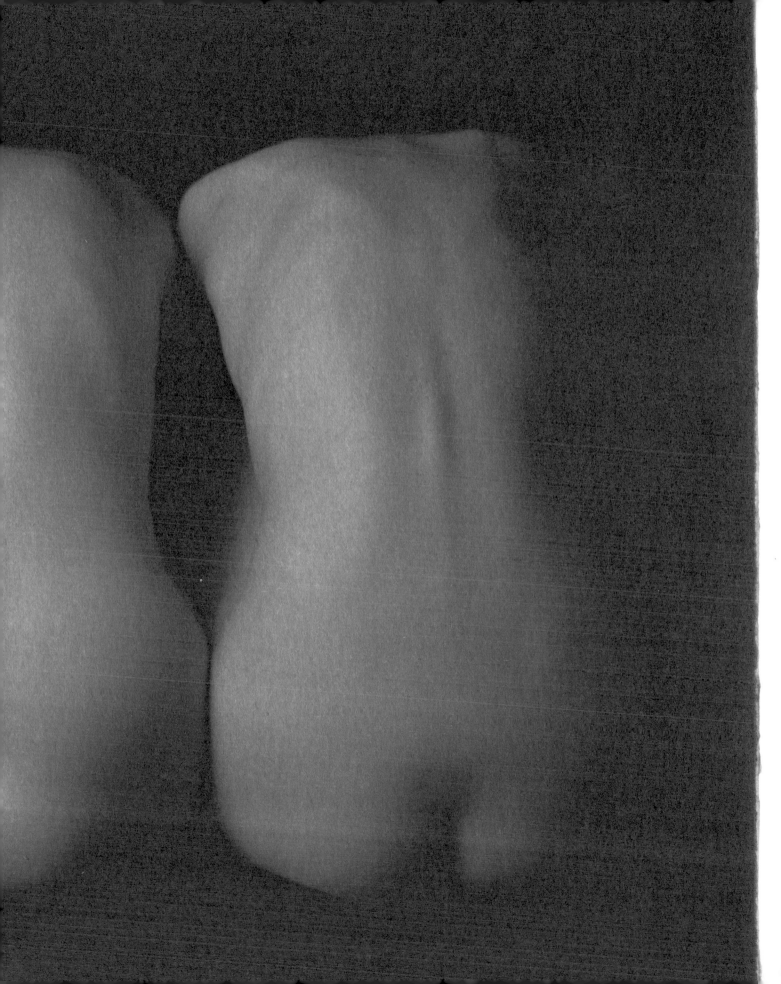

structure underscores the image.

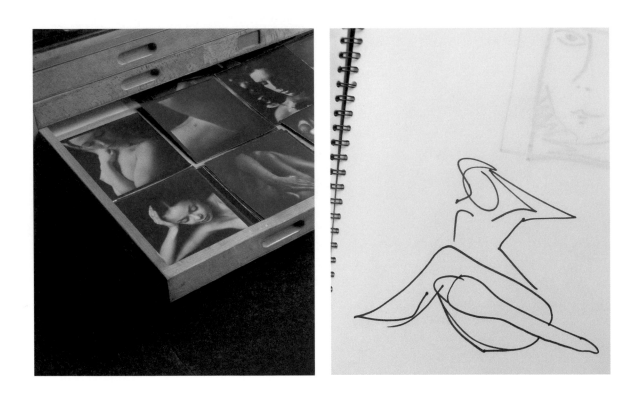

Sense and order help to control direction and put emphasis on intention, reminding us of what works and what doesn't – important as we're trying to make images for a receptive audience. Through sense and order, also, we can see progress. A notebook is a map – a window on our world, providing a sense of place and helping us answer the question: 'Where do I fit in, photographically speaking?'

Sense and order
Good storage means having easy access to one's work, so that we can constantly review our photography and be surprised by each re-view of an image.

Preparatory study
Sketches are something to act on in the search for *'sense and order'*, and also provide a much-needed place to come back to after a shoot, to reflect on what was achieved. A case of *'concept to realisation, and back to concept again.'*

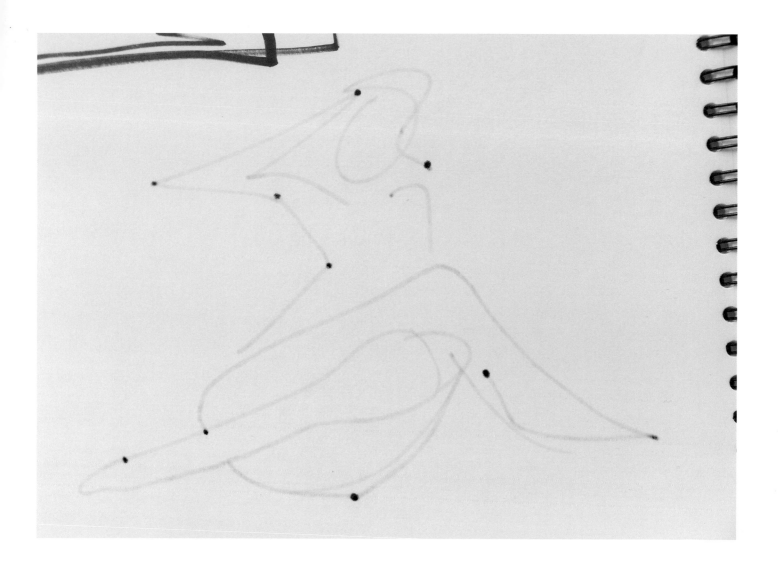

Only through the continuous discipline of practice - note-making, sketching, photographing, editing, printing and critiquing - is it possible to transcend the obvious application of technique.

An invisible approach

Like many of the simplest, yet most successful photographs, the free-hand drawing, opposite, appears *free* of technique. By chance, backlighting reveals a clear, but subconsciously created, join-the-dots-type structure, above, with each dot marking brief pauses or changes of direction in the journey of the feltpen. Seen this way, the image is broken down into its component parts and the artist's approach – his sense and order – and application of technique is revealed.

With practice, it is possible to look at any photograph (not just our own) and understand how it was made, from concept through to print, although realising 'why?' may be harder.

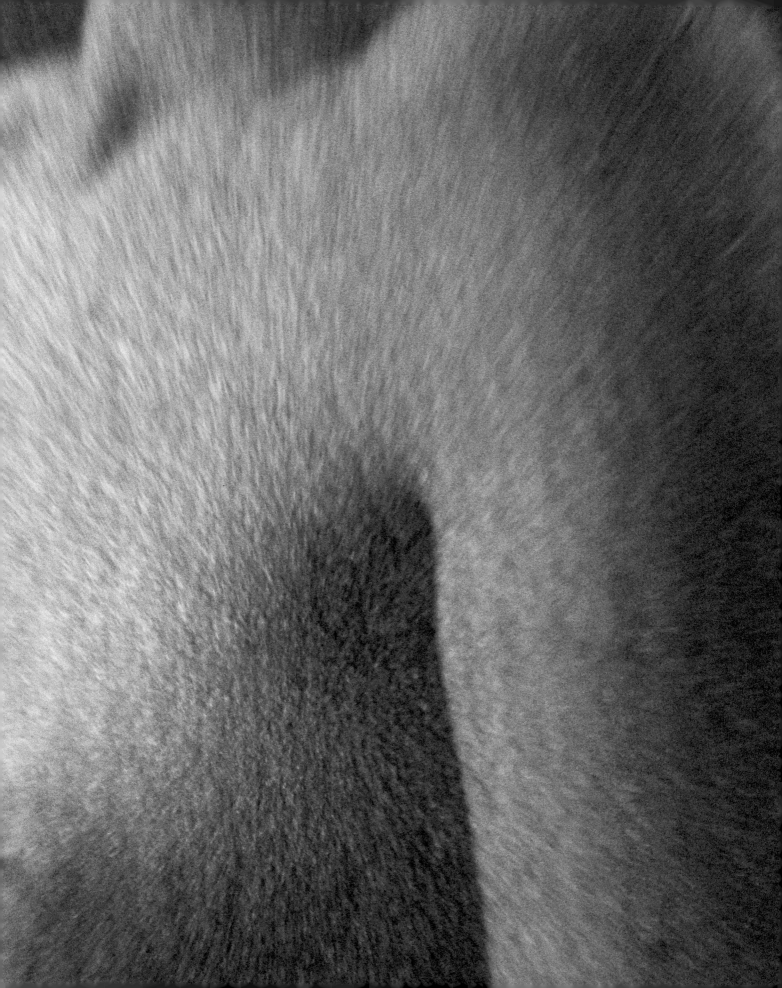

Working in series, experimenting within boundaries: Sofa series ~ Circle series ~ Geometric series ~ Organic series ~ Lips series. No art would be advanced if we didn't experiment all the time.

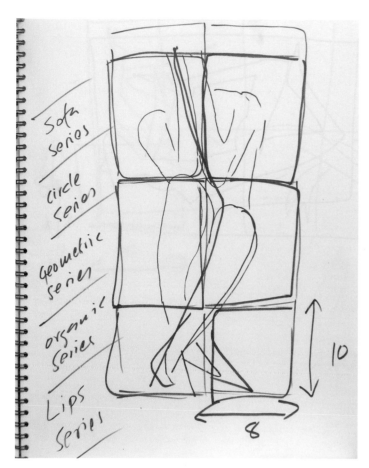

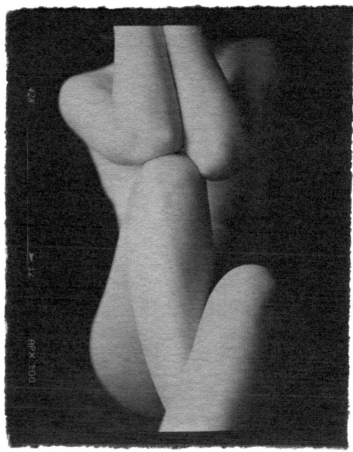

Experimentation and spontaneity

Break the mould and find the new. Look at what's familiar and discover the alternative. Reinvent and originate. Try a new way of photographing.

The creative process seems full of such contradictions: perfect a technique – yet experiment; develop a style – but look at things differently; focus – though try not to be so implicit; work to a plan – be happy to improvise. Just as we think we're getting there, it can all appear to be falling apart. Imagine the alternative.

Do we always want to control what we do and recognise the pictures we make before they are printed? The traditional ground-glass viewfinder presents a back-to-front, upside-down view of the world and subjects are perceived in a fresh light. Bold compositions tend to follow.

Fragments

'Abstract bodies – body parts – can be more interesting to look at when everything isn't revealed and the subject remains anonymous.'

A test-strip also works as an unintentional abstraction of a larger image and may get to its essence, comparable to a crop that eliminates excess.

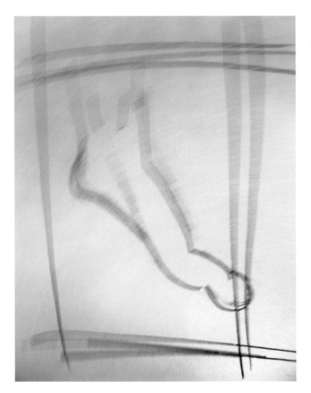

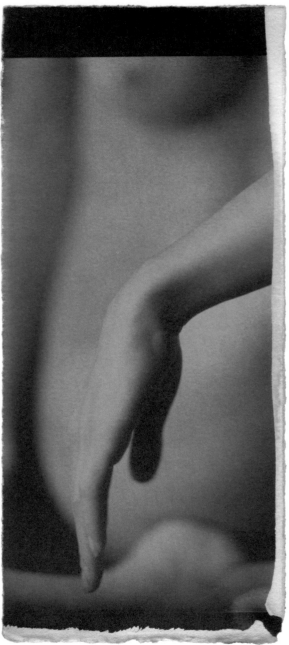

Drawing the eye
Selective focus and limited depth of field are tools that help establish the hierarchy of an image, with the viewer's eye deliberately drawn towards even the tiniest of details.

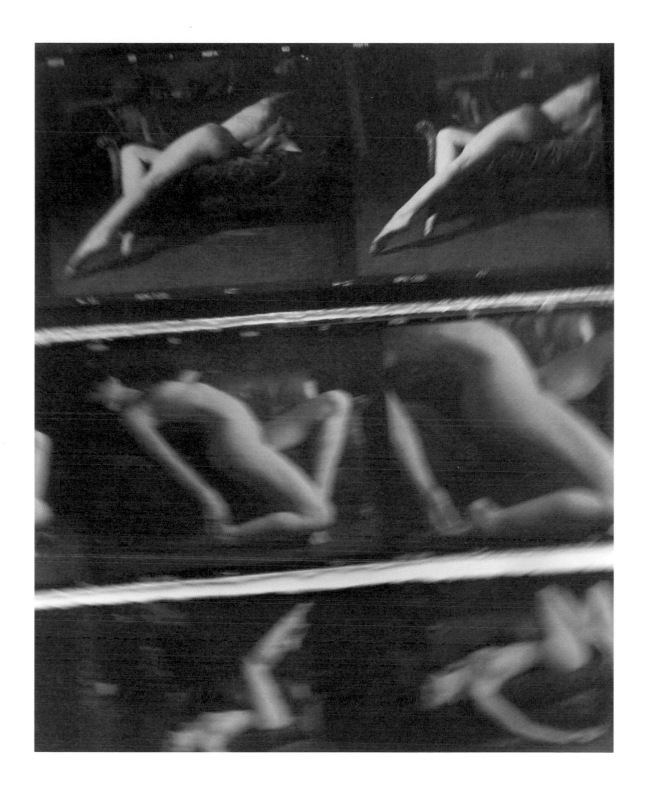

Anika's sofa series
Allan almost always uses the round table in his
studio as the setting for his shoots – *'it is a stage on
which people can perform.'* In contrast, he
experimented using the model's own sofa, here to
create interaction between its shape and her form.

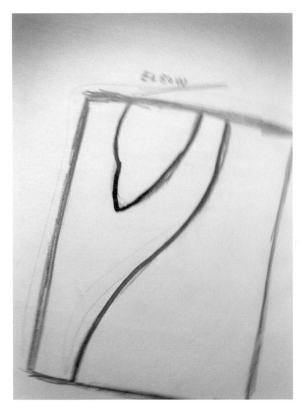

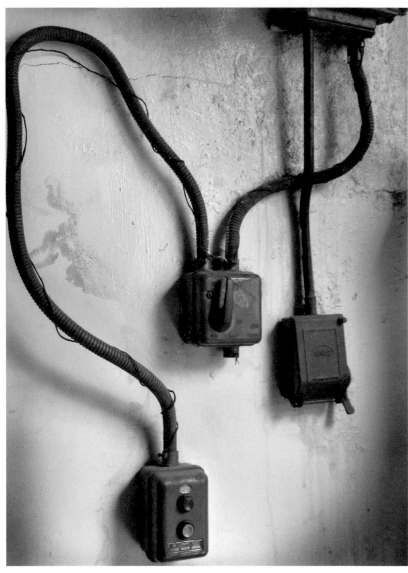

The more we search for self-expression, the more we see potential in everything.
Some of it inspires us subconsciously, some consciously.

Art imitating life…life imitating art
The line of *Elbow*, the sketch above, echoes the
curves of an electricity cable in the studio. Is this a
case of pure coincidence, or has the influence of
environment been at work? A similar shape can be
seen in another of Allan's notebooks, opposite.

The adrenalin is flowing created by creativity itself, caused by the certain and continuity of our discoveries.

 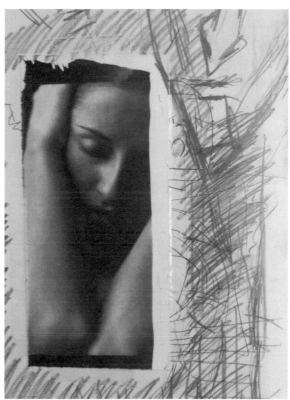

Progress in art…Picasso took cubism to the limit. All artists want to see how far they can take their approach. When mine stops working for me, I'll move into another phase.

Thinking visually
How does the mind translate visual ideas into a creative response? Is it a logical process, or a sequence of random, yet somehow connected thoughts?

*Images are immediate,
yet can be reinterpreted
again and again.*

The print as a notebook

'I first experimented with writing on my prints during the making of this book. Prints become notebooks themselves. Also, they can be visually attractive. Red chinagraph, for example, compliments a warm, blue-brown toned cyanotype and pencil writing is metallic looking, which works nicely with the ferric-based cyanotype process. In art, signatures on paintings have always been considered an integral part of the art-piece. They tell us something the image itself can't.'

Florence Torso

Transcript:

The body itself conceals and reveals what is necessary. Doing so it creates nudity without nakedness, the purest form of abstraction from an identity that once existed, and has now been obstructed. The body is creating its new identity by hiding the obvious shaping and only revealing the desired form, thereby creating an overall new figure. Through this figure we have been able to transmit the message of abstract nude, and that expresses nudity without nakedness. For this reason alone, it allows us to explore further. Florence, a posture that clothes the nudity with the body itself – arm becoming shape that conceals.

necessary. *unclear* nakedness. the press *unclear* of *unclear* identity that once existed, *unclear* now been obstructed. the body is *unclear* its new identity by hiding the obvious shape, and only revealing the desired *unclear* there are creating an overall new f*unclear* Through this figure we have been *unclear* the message of abs*unclear* expresses nudity *unclear* nakedness for this reason alone *unclear* are further. *unclear* the nudity with *unclear* shapes that conceal

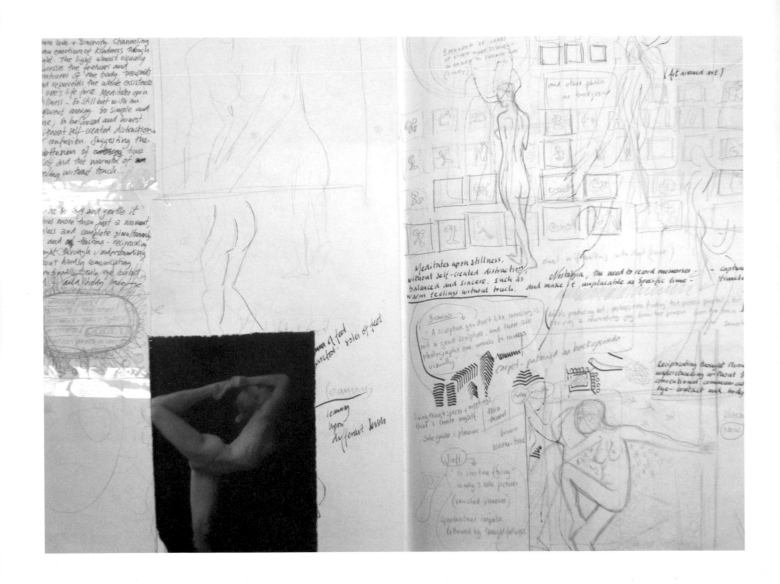

I find that, in photography, we learn a few ideas, then we start to put words together to have a conversation. Then fluency arrives when we have made up our own language. Any artist's work is their personal language. In my case, it has evolved through a series of influences.

Opposites pushing against each other,

creating balance and harmony.

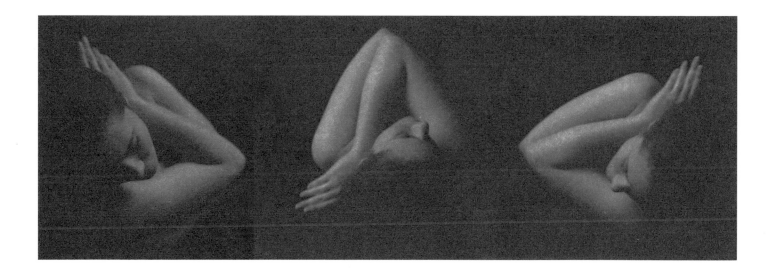

Second nature

Everyone can take a picture, it's true. Those who haven't yet tried may think it's easy. Those who've tried a little, think it's hard. Those who've tried for longer, think it's harder still. Perhaps those who've made pictures for a considerable length of time simply forget to think about such matters.

Constant practice helps us create a personal, visual language with its own vocabulary. We begin to sense what's going on as we make images, but we can't necessarily explain it. That's the job of the photograph and of the language of the print.

This second nature is capable of creating great images for us, but it can't tell us how – only that it is worth continuing our efforts. The satisfaction that comes through second nature's unselfconscious state of flow tells us this.

cropping in the
viewfinder, until
balance of lines
makes sense as
a whole and
captures details
within

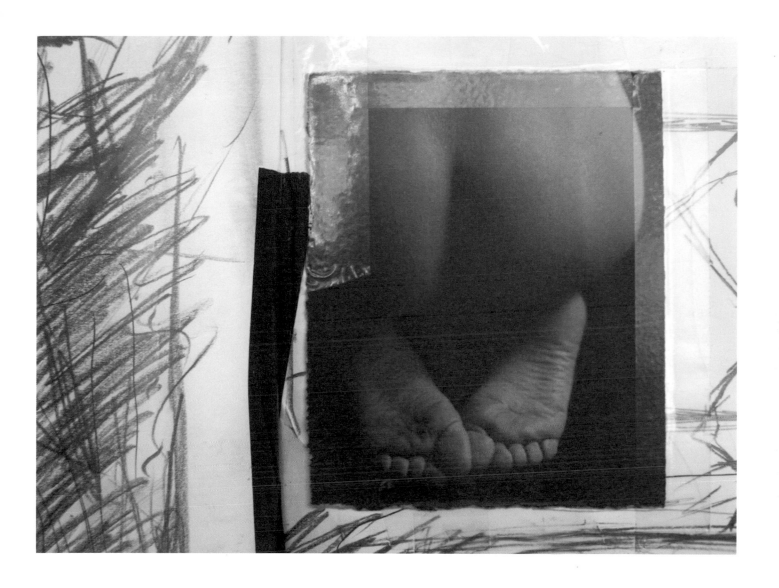

In future, when I frame my work, I would like to include drawings, or a page from a notebook.
It could say a lot more than a single print. The process of the shoot, including the drawing and the
final print, all framed, would make a more complete story.

Experiment. The camera is only half the picture... I'm always concentrating on the image, rather than getting lost in gimmicky technique. Everyone has a different way of arriving at what they want to achieve.

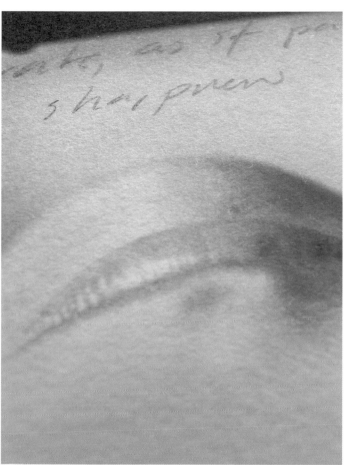

Don't let the energy go in too many different directions, by thinking about what camera or method to use next. I don't want to be a jack of all trades, but a master of one. Yet within that trade I can apply the same rules to all subjects.

3

photographs

An image that captures
more than just a moment.

NUDES WITHOUT NAKEDNESS

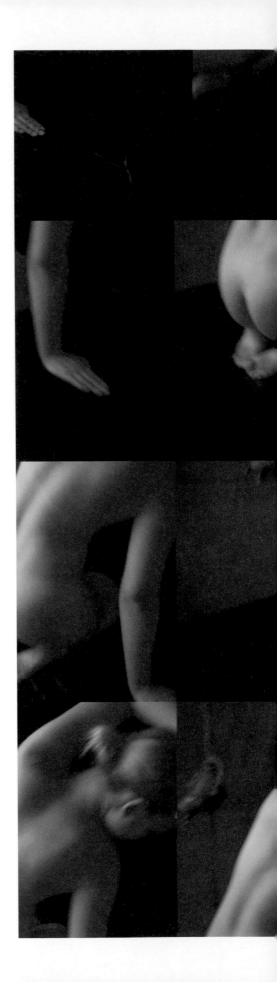

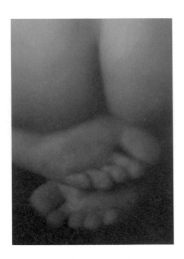

In creative photography, we look for meaning beyond what process itself can express. We search for something that helps us understand what our chosen subject is *really* about. But what if it is true that photography is only capable of describing everything yet explaining nothing? How, then, do we convey our ideas? We can't rely on 'naked' truth to speak for us. Photograph the spirit and not just the form.

Sonia posing
Searching for the perfect shot, the eye scans the body for the right light, angle and shape. The idea is not to give it all away, but, through suggestion, create something for the viewers' imagination to play with. Creating acceptable, yet challenging images is, surely, more inspiring than trying to provoke for the sake of it.

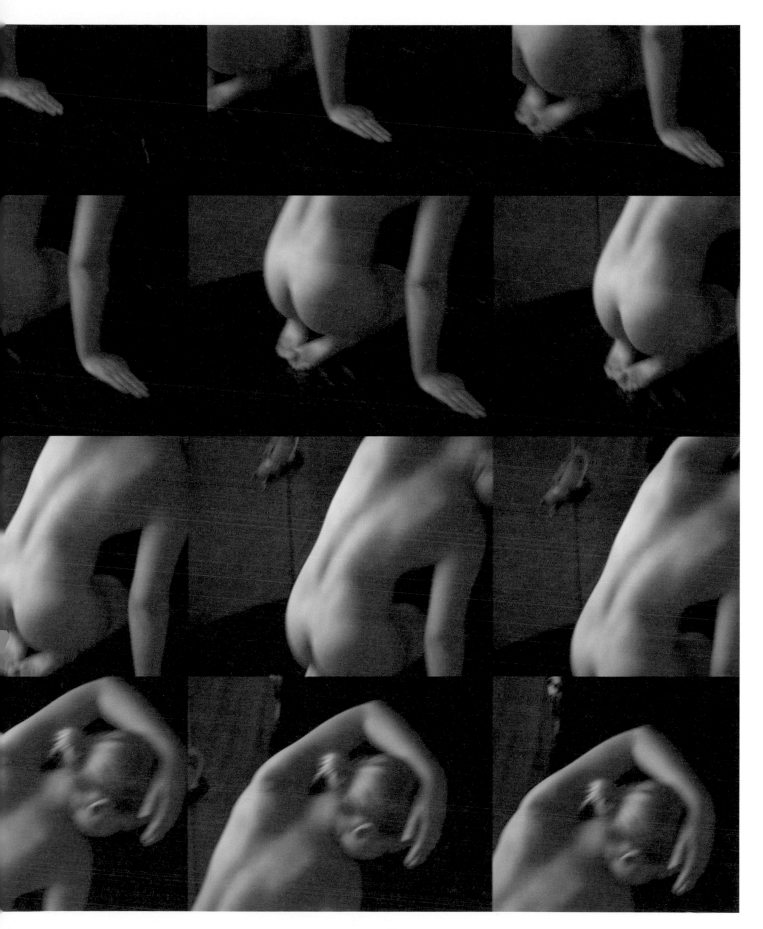

Real people, not models.

…with very little command of instructions on what they should do. It's more like, 'Please move around very slowly' until something happens. And, as if by magic, something always does. That's when I say, 'Hold it', for at least a few seconds while I make an exposure.

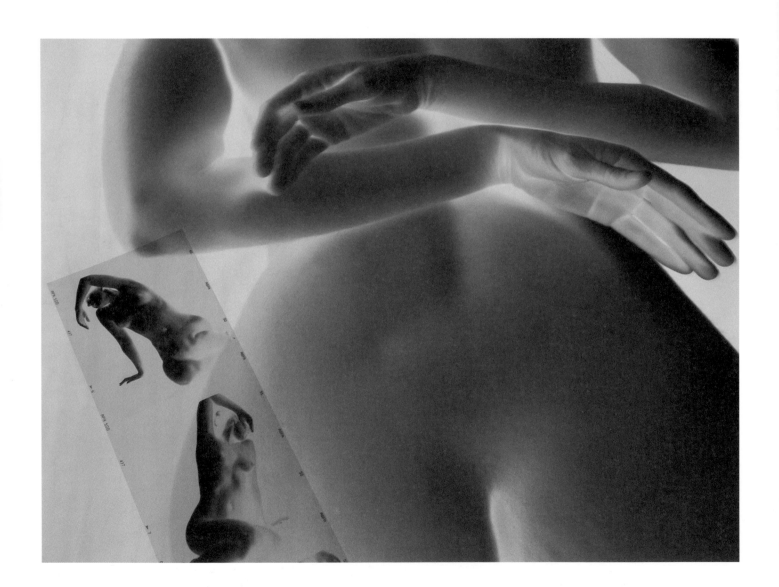

A question of scale
Allan employs various camera formats, from 6x7cm
(for experimental work), up to the giant 24x20 Lotus
View Camera. His nudes are normally made with a
10x8, and their negatives contact-printed. Anything
larger can reveal too much detail.

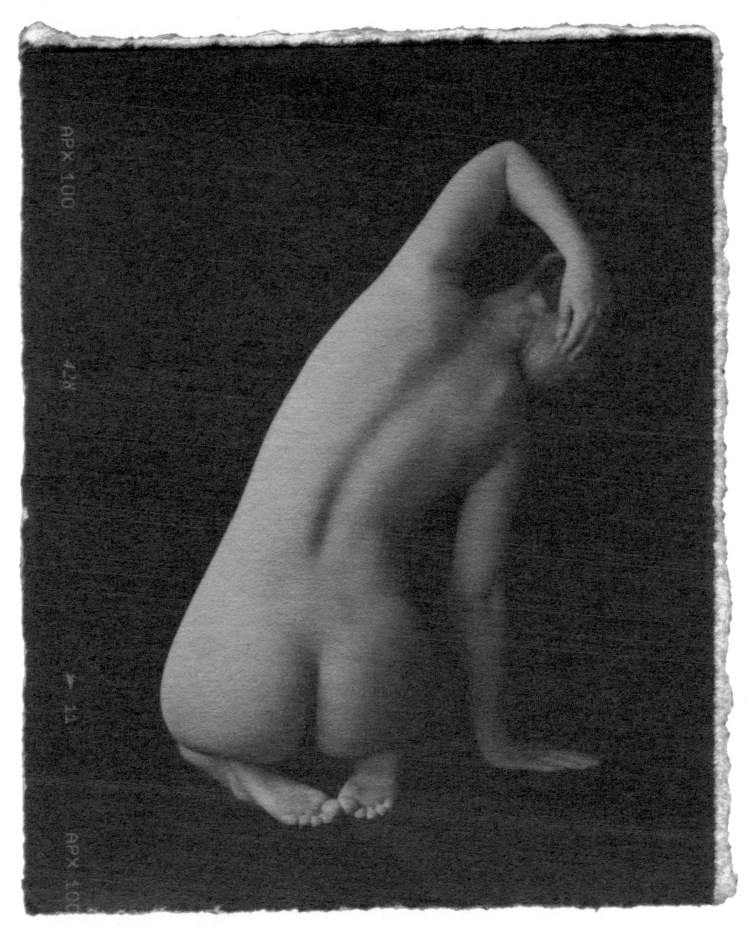

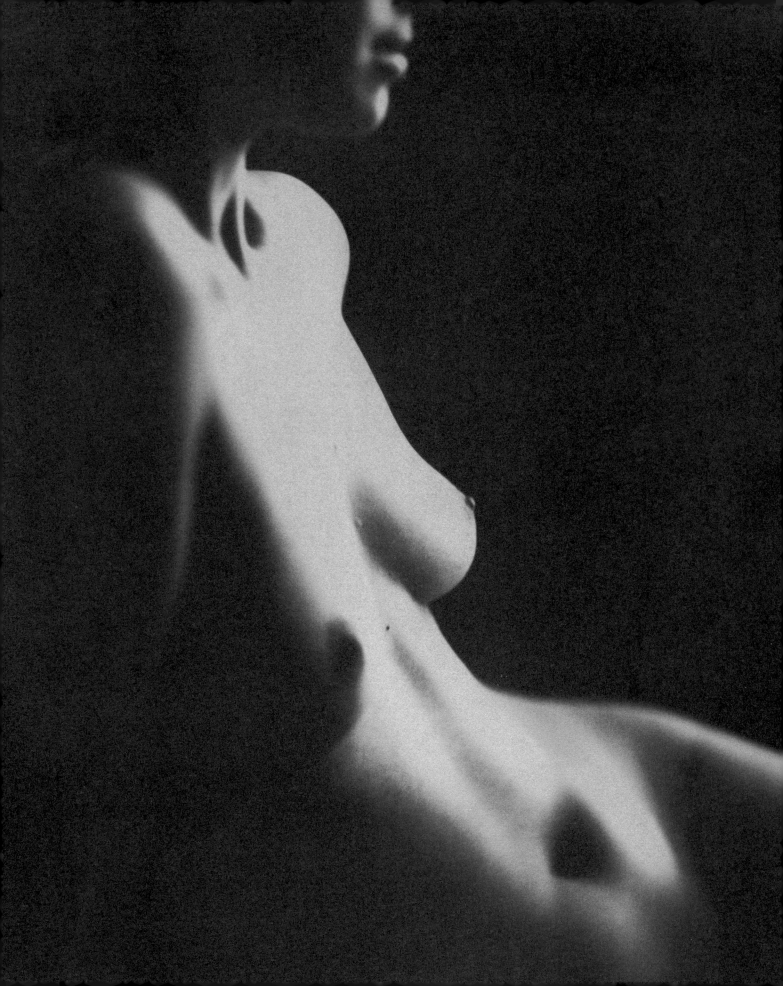

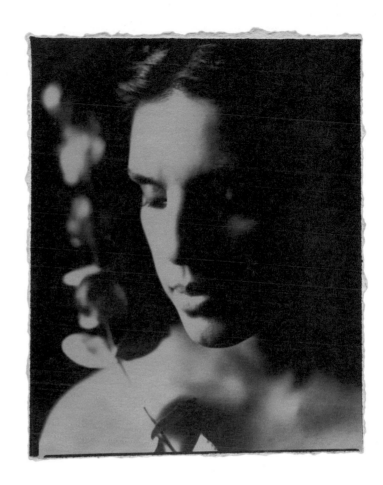

Gregorian chants, Arabic sounds, classical piano, harmonious music without lyrics, some composed by a friend – sounds joined together, creating a journey, not a conventional composition. Music helps keep the flow. If the music stops, the shoot can lose momentum.

Mood and atmosphere

The body is moulded by life changes and it is shaped, too, by the very process of being photographed. The experience transcends photographic technique in a search of fulfilment for both subject and photographer. It culminates in a state of photographic communion: photography as mindfulness, posing as celebration. There is no better subject than self-realisation. Photography is about living in this world.

Just as landscape photography might be seen as a search for outer freedom, nude photography could be described as a quest for inner peace. The sanctuary of the studio is therefore all-important. To quote Allan: *'Employ ritual…switch off phones, no abrupt interruptions, no-one knocking on the door. It's meditation time, achieved through moments of peace. Models may arrive, having travelled by tube or public transport. They come in to the special world of a studio and leave chilled out.'*

Mood and atmosphere is everything.

Blue and tanned, green and brown.
Warm and cool, fragile but firm.
Colours that blend into each other.
_ muted, no primaries.

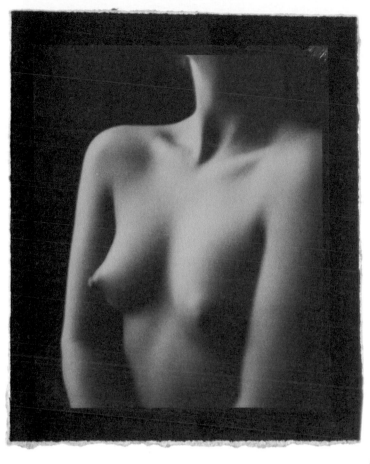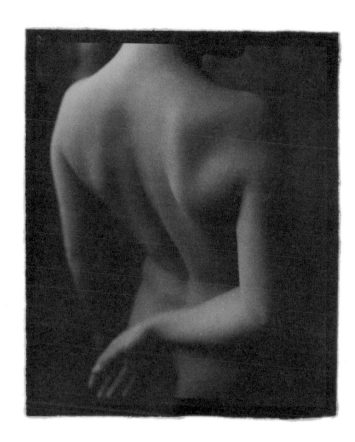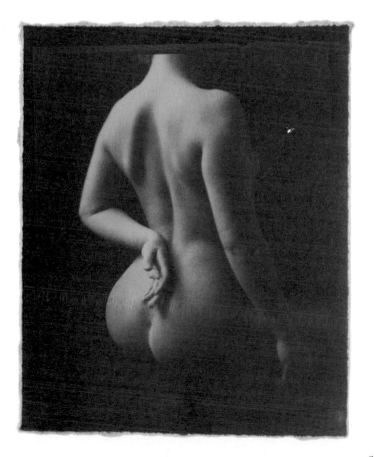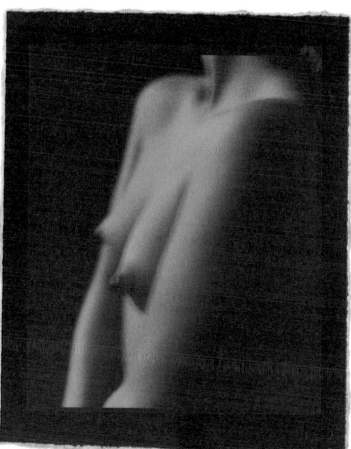

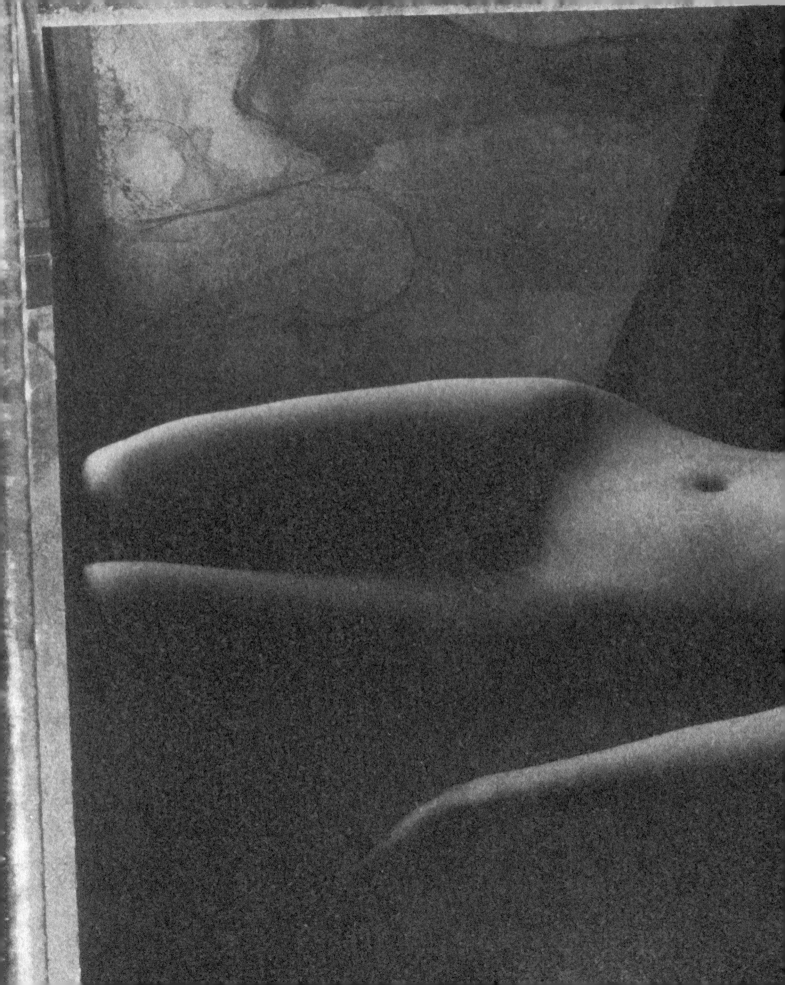

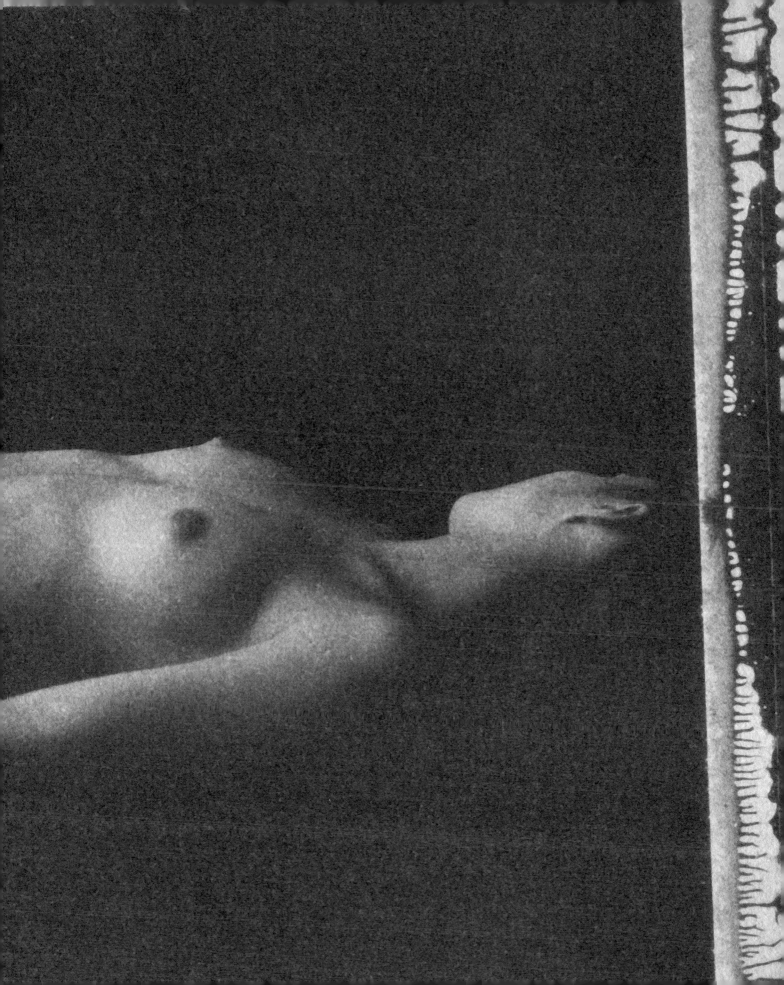

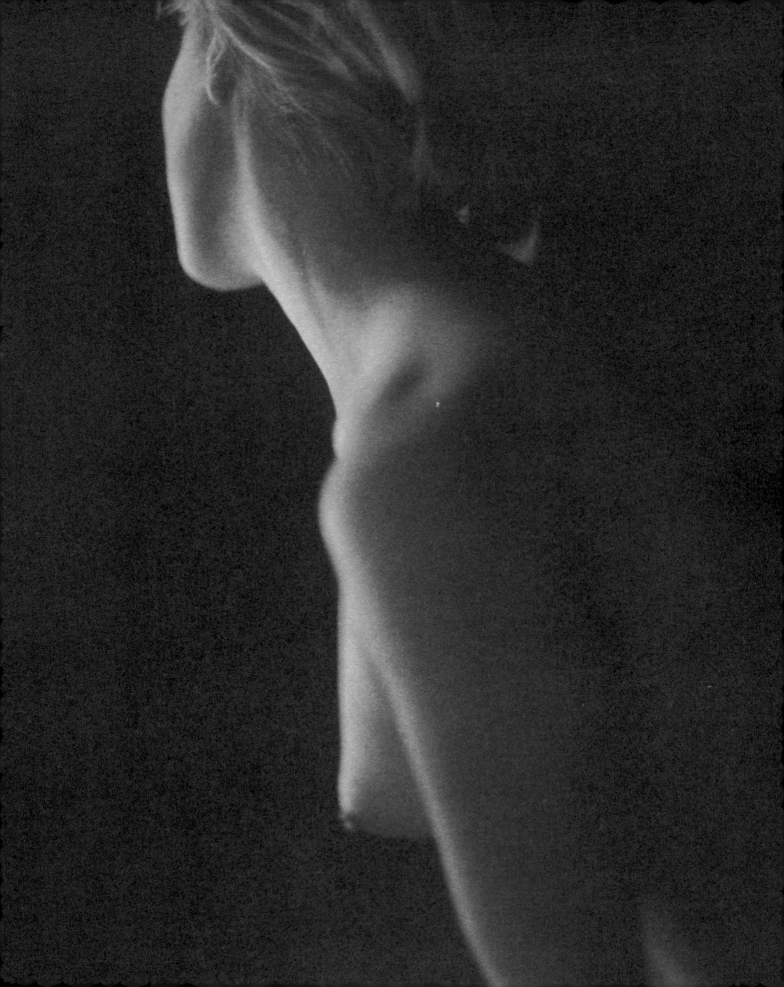

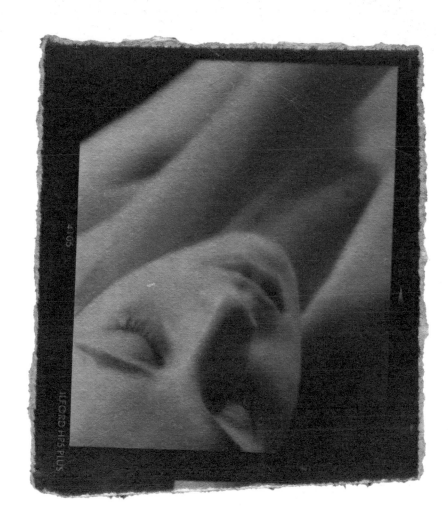

Controlling negative and positive spaces.

Shape and form

What relevance has detail? What story does it tell? In the transition from camera to print, what information do we need to retain, enhance or lose? Less information can equate to greater coherence: the viewer gets a clearer sense of what the photographer is trying to convey. This could be as simple as 'shape and form.'

Printing with an old-style process, on handcoated paper, much detail can be lost. This can help a photographer whose aim is to guide a viewer towards experiencing the intention of the picture. Through such realisations, the viewer is free to create their own portrayal of the subject and to draw new conclusions. The viewer becomes the artist. Simplicity can open many doors that the undisguised or overly detailed image hides. Nowhere is this truer than in nude photography.

A quiet way of working.

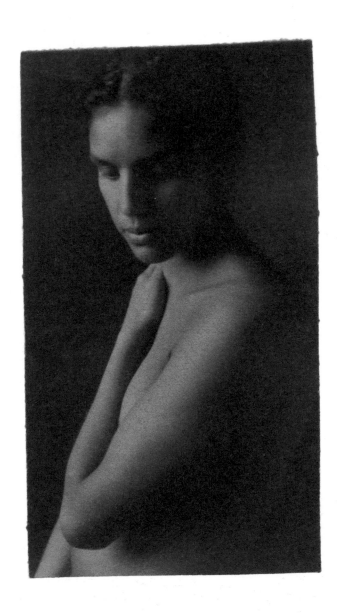

Nothing goes to waste. When I do a contact sheet
it becomes a print, when I do a test-strip it goes
in my notebook. None of it is more than the other.
I like to think I could frame the notebooks. Art is
no longer just about the destination.

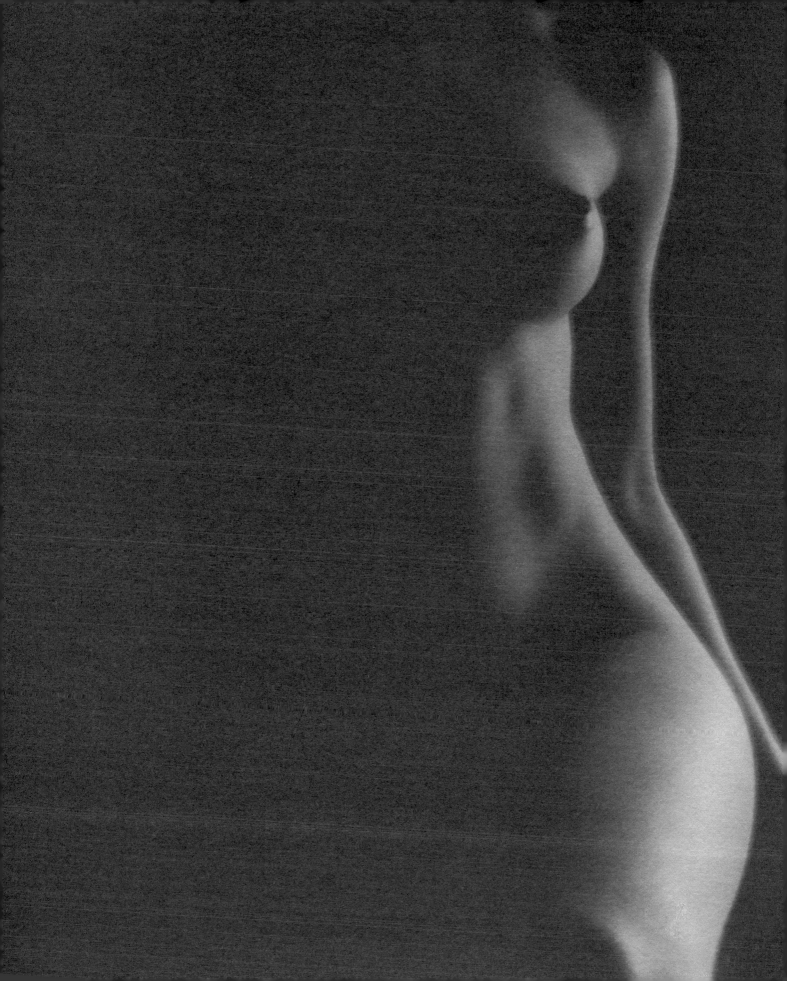

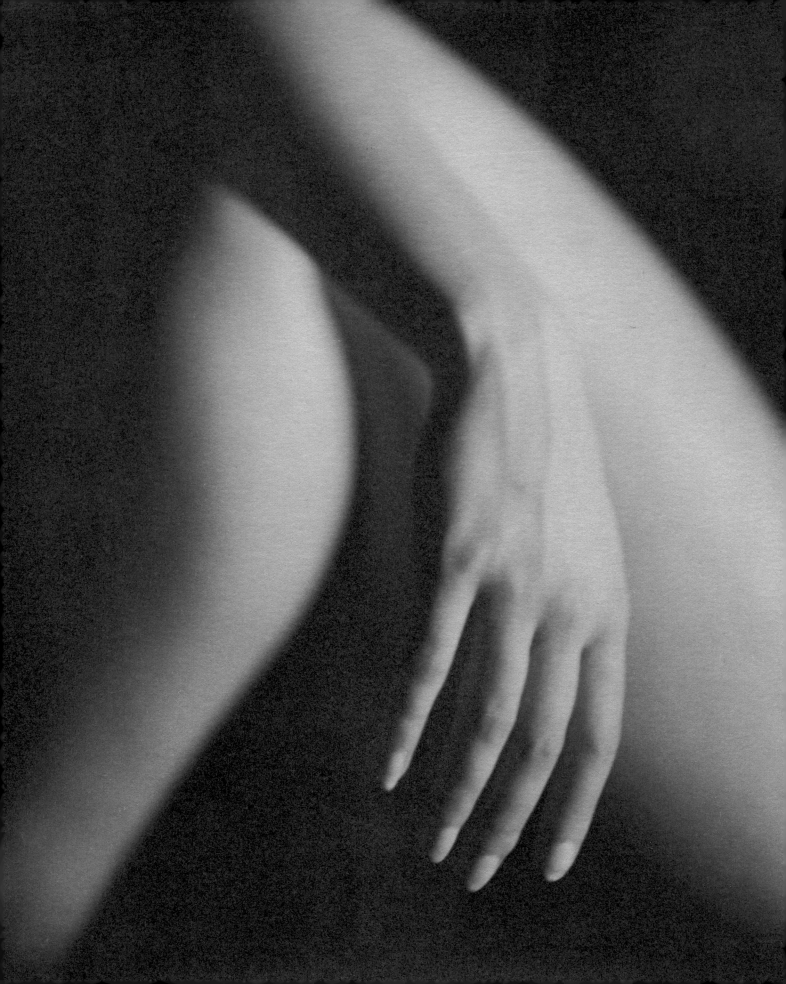

A balance of negative space around a positive form.

All the forces come together to create balance and harmony. Harmony is an enjoyable way of working - our practice of photography itself becoming a source, and an effortless way. Initially it can be a challenge, but once you know the direction of your work, it helps the flow, found by following one's instinct.

Balance and harmony

There will always be a struggle between presence and absence: what we include versus what we take out. This raises the question of how we achieve balance and depict harmony – even if the image aims to unsettle.

Harmony cannot occur without the balance of the 'other': impulse is connected to action, influence linked to origin, process allied with technique…light balanced by shade.

The photographer can bring the hidden to light and form the complex from the simple, but ideas need to coalesce before balanced images can unfold. In the studio we are able to experiment and to go back to a subject and, through a notebook, we can explore it further still – a case of seeing arousing greater vision.

Adding elements, taking others away.

When people ask what medium I work in, I say ideas. I'm not a technical person,
I don't even have shutter speeds to play with. I just remove the lens cap to make an
exposure with my 10x8 camera. The camera is the mediator.

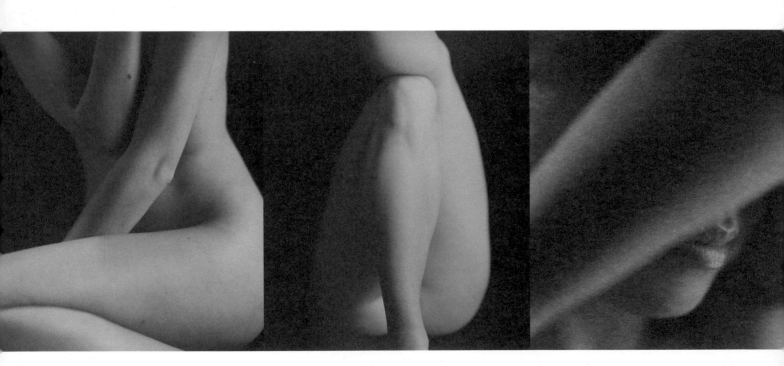

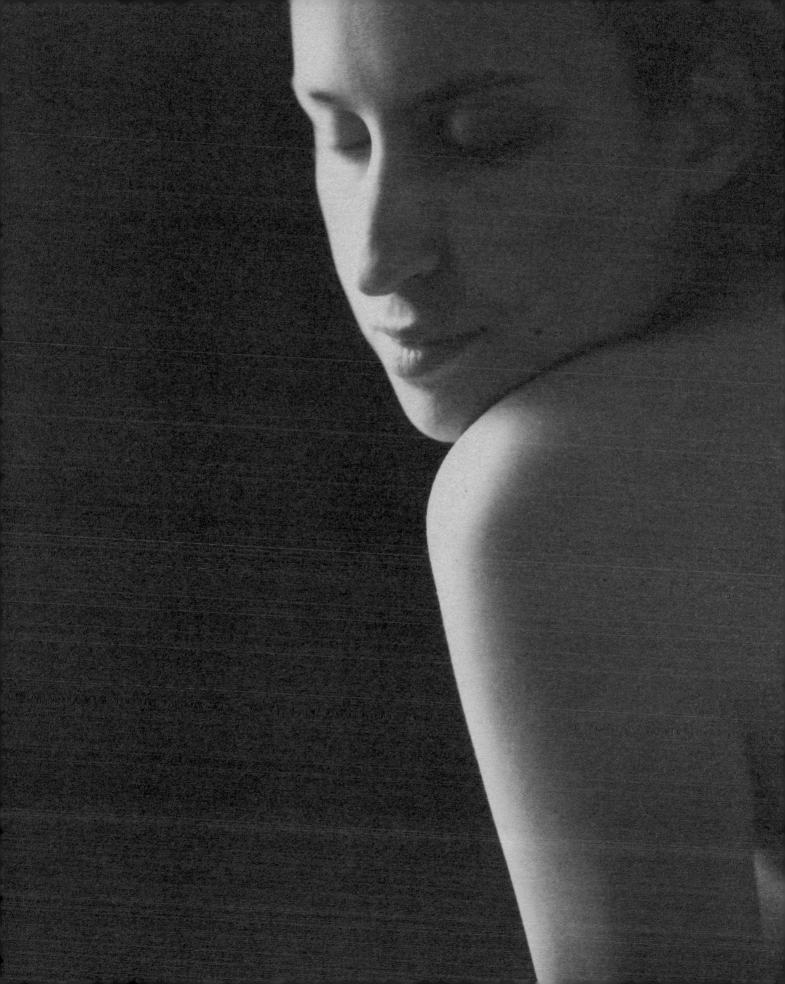

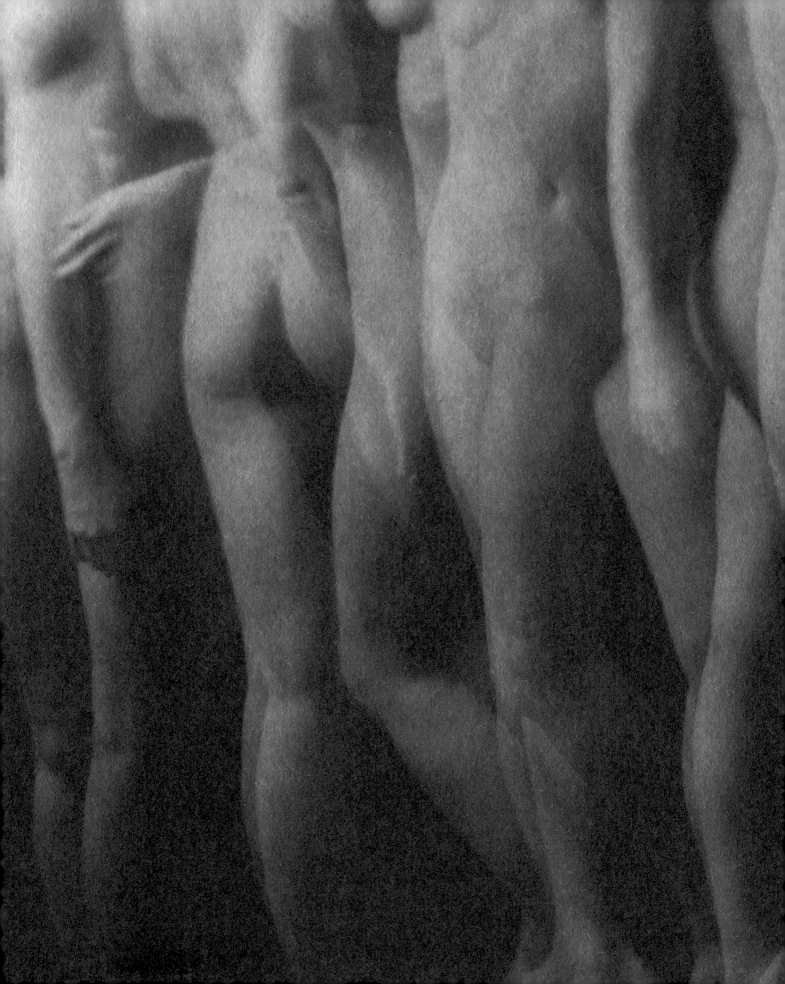

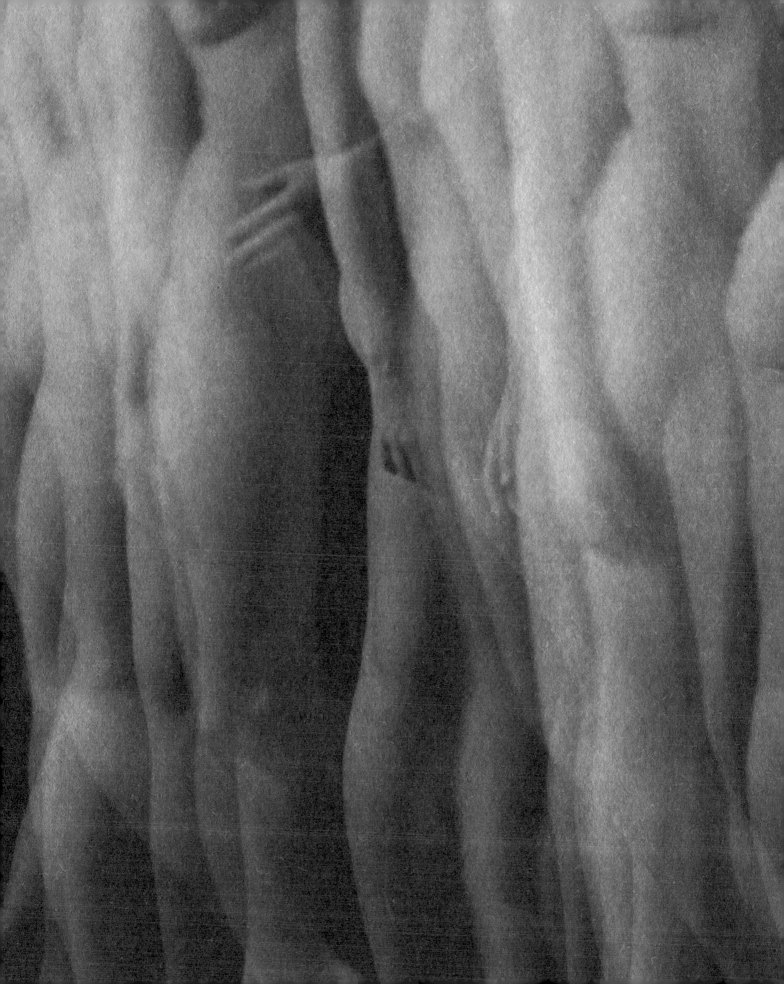

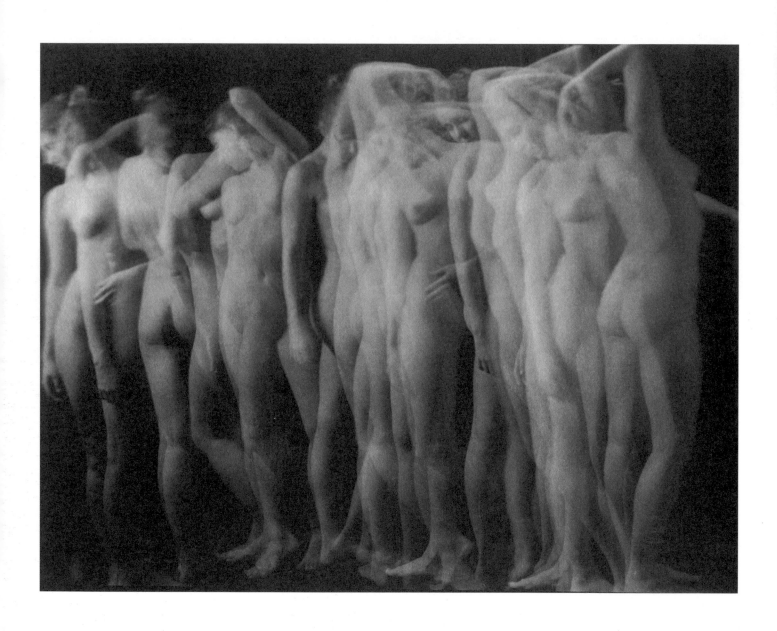

Be creative with opportunities.

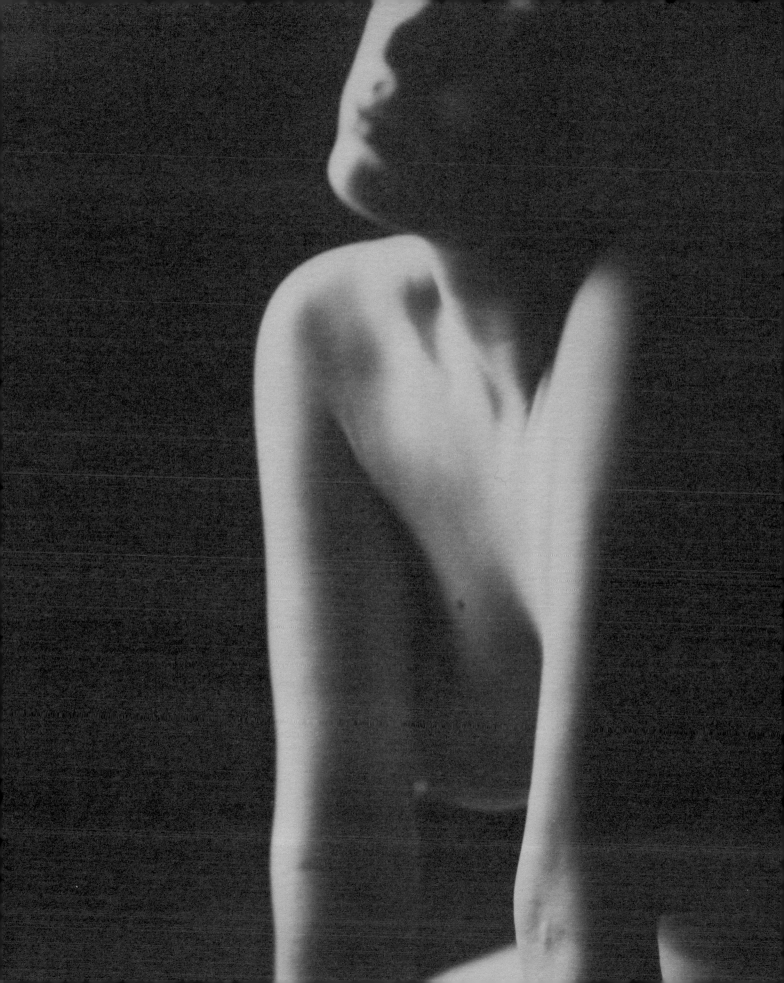

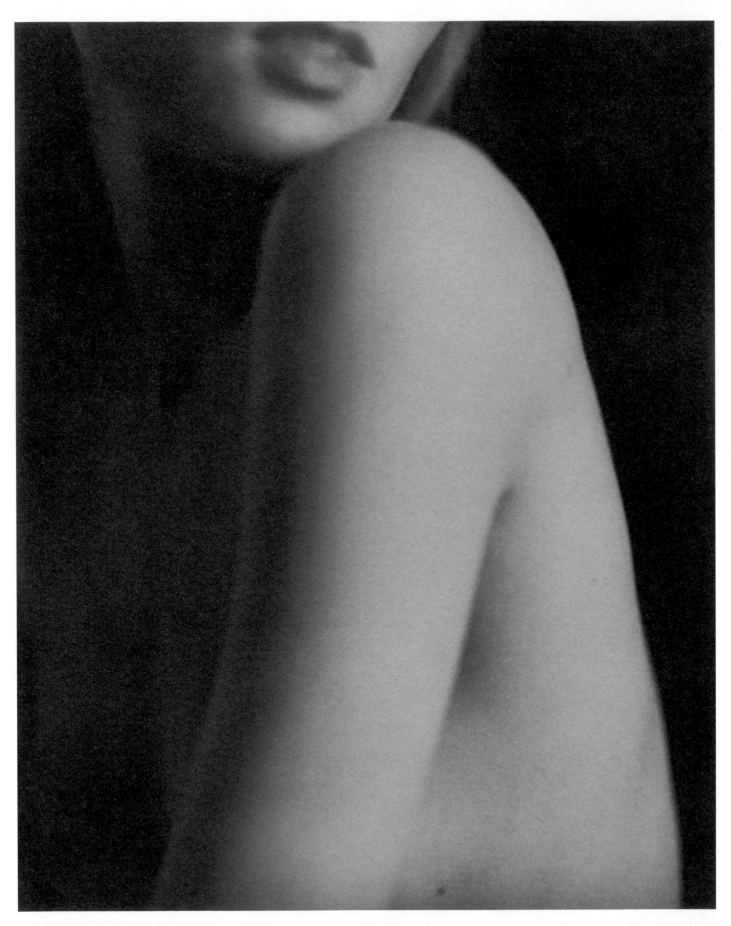

An abstract nude - an interpretation of itself.

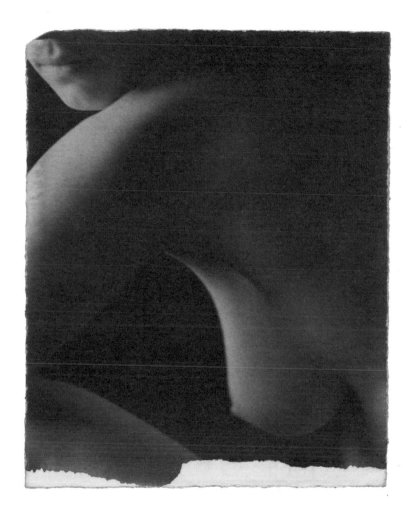

Sensuality and intimacy

Photography's finest moments are when we forget it is photography. And nudes work best when the subject no longer feels naked.

An unselfconscious approach to creativity is essential, whatever the subject matter or the medium. But closeness cannot be achieved with the distancing effect of a long lens, nor affinity attained by sheer proximity to the subject alone. Something else has to be present to create sensuality and intimacy, to generate what Allan might describe as *'nudes without nakedness.'*

What bridges the divide between photographer and subject might be achieved through a combination of factors: a well-practised familiarity with one's chosen medium, confidence in one's technique, and clarity of purpose. And if the subject senses the photographer putting themselves in the picture too, so to speak – connecting to the obvious vulnerability of being naked – might that willingness to be intimate close the gap, allowing sensuality to permeate through?

Contrasting elements: the soft and the sharp,
the warm and the cool,
the deliberate and the spontaneous.

Where do ideas come from - something someone tells us, or something we hear within? If we're lucky we might actually come up with a good idea or a thought that develops into one. If we copy, it won't have the same essence. The difference between those who copy ideas and artists who develop their own is obvious.

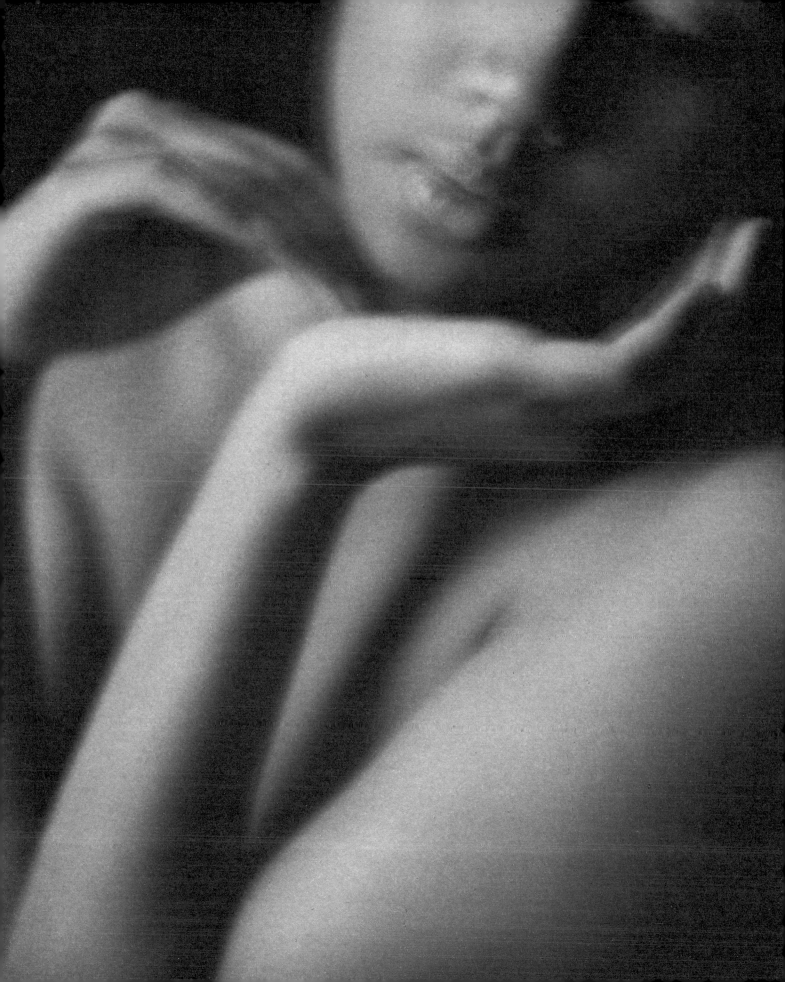

4

technique

I tend to apply a series of unspoken rules.

The opaque blues and musty greens combined with the
tanned highlights are soothing and blending
with each other. Most... predominant key, almost
comparable to painting... fically from the
Renaissance period... chiaroscuro eff...
was predominant. Bringing the light out of the
darkness

The work is full of co...
...cate at the same time...
...ley and carefully achieved...
...but firm. High contras...
...ft highlights. All the co...
...nking gradually into...
...colours, no primaries...
...beauty of musty green
blending into... ...ssed by the warm
highlight that helps the image project itself
away from the... ...ively background

THE ART OF TECHNIQUE

All art involves technique. The real art is in personalising a particular method, to make it our own and to keep it simple – in Allan's case, the cyanotype contact printing process. Fluency comes with practice and may take many years to achieve. And what could be simpler and more effective than always working in the same way, in a studio, with a large format camera, one tungsten light and a traditional contact printing process?

Raw ingredients
A simple combination of two chemicals: ferric ammonium citrate (green) and potassium ferricyanide (orange) make up the raw ingredients of the cyanotype process, that has been around since 1898. In creative hands, it is capable of producing exquisite results and is limited only in that it is a contact printing process – the image can't be enlarged in the traditional way, other than by making internegatives.

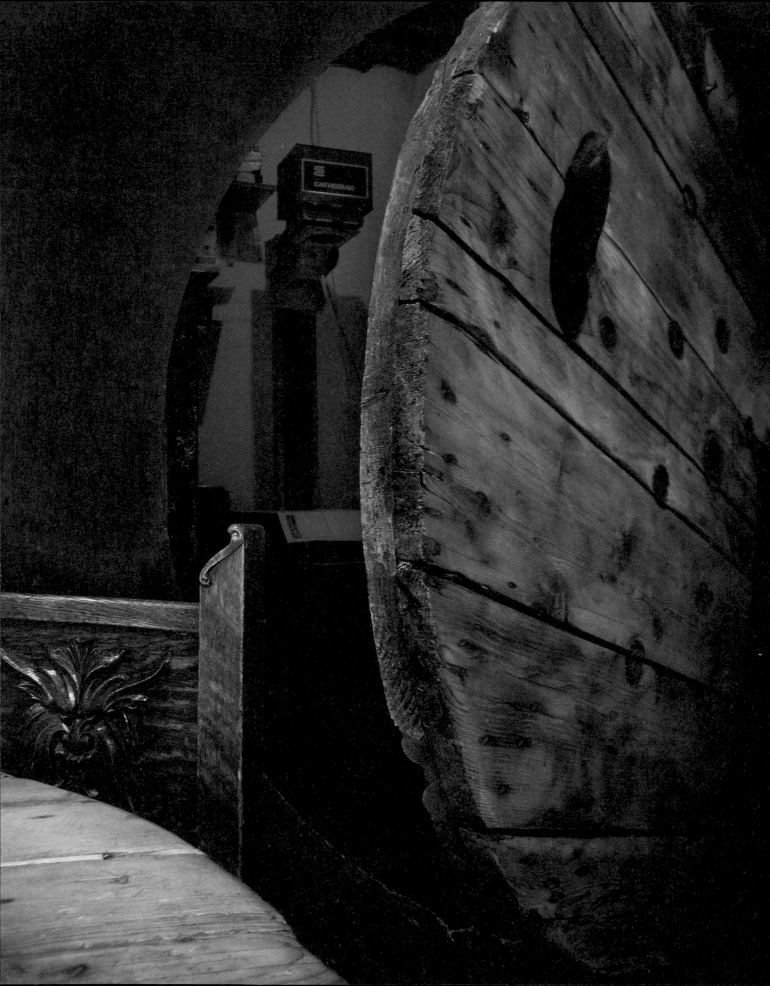

The environment I have created reflects my style and approach.

Enter the darkroom

'From light to darkness to light,' is how Allan describes the experience of working in the darkroom: less a physical space and more a journey, or a mantra in the quest for creative self-expression, echoing the old adage, "Man is a seeker. He dwells amid shadows and seeks the light."

Might the darkroom, therefore, be a place where we transcend technique? A place to meditate, to connect with our creativity and to go beyond, to arrive at a state of photographic 'being'?

The darkroom is often seen as the most technical stage of the photographic process. If so, how do we prevent technique getting in the way of the creative journey? Keep the process simple and pure, have faith in it and allow the rest to happen, perhaps? Magical possibilities lie within its confines. The discipline of perfecting a single process is one way we can access what lies 'within'. In Allan's case, he has been practising the cyanotype process for twelve years, every day of which has revealed new possibilities.

Through the door

The round darkroom door is the second half of a giant cable-holder, whose shape, coincidentally, is echoed in the carpet inside. It serves a function as well as an aesthetic purpose: *'A black curtain behind keeps out any stray light. Also, I've used it as a backdrop for shoots. People are drawn to it.'*

Between the darkroom and the print, looking in detail, the image can be seen on another level. It's all part of the process of creating sense and order...can't live without it. It's indispensable. Editing is an important part of the image making process. What we choose to leave out is an important part of the artistic process.

Editing the images

Magnifiers and scissors may seem outdated in today's world of digital cut-and-paste. Yet traditional darkroom practitioners might argue that they provide a physical and more intimate connection with the image making process, whose benefits speak for themselves.

The old and the new

Making a traditional, 'wet' print is a time consuming – *all consuming* – business: process the film, dry it, cut up the negatives, contact-print and edit them, then make internegatives (for contact printing processes like the cyanotype). Prepare the sensitiser solution, coat the paper, dry it, expose the image, process the print, dry it, flatten it and, finally (if the result meets with approval), retouch it.

Of course, normally, one would not expect to get the print right at the first attempt. All sorts of previously unseen elements within the image may have come into play, or the coating may not be quite right. So, the process is repeated – and again, if needs be, and always with that element of uncertainty.

Unlike new digitised methods, in the traditional darkroom there are no guarantees, but there are always unanticipated rewards.

Formulas are options, rather than science. We don't need to know about chemistry, other than how to choose which formula to use. Chemistry is just the vehicle for the message…the effect we hope to achieve.

Part A – Part B
This formula for the bleach part of sepia toner is found in darkrooms the world over, yet this one simple process is still capable of producing ever varied results.

Potassium Ferricyanide

Potassium Bromide v

2 tsps each + 2 litres H_2O.

PART B - Toner

Sodium Hydroxide 15...

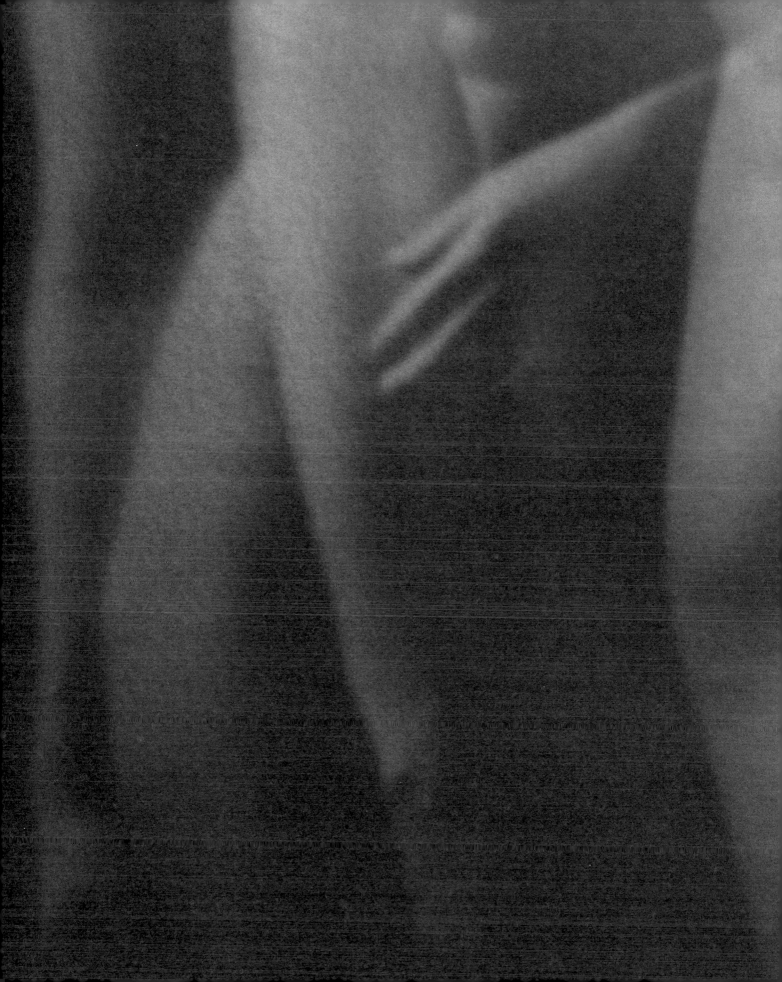

In the darkroom, everything gets filtered through technique. Where is Photoshop taking us? What does it do to the printing process if we can totally control the image before we print it?

The chemistry

Has the chemistry of photography changed with the arrival of digital? Not if photography is still about the magic of seeing one's ideas appear. In which case, isn't digital just another way of putting our mark on a sheet of paper. The real question of chemistry is deciding what our own, personal formula is.

The digital workstation has largely taken over from the darkroom because, as part of our formula, it *does* promise certainty and, in the right hands, it *is* capable of producing consistent and predictable results, print after print. But what price assurance? Hand-make an edition of, say, 18 prints (Allan's usual number) and for sure one print will stand out better than the rest. Another may be so surprisingly different as to suggest an alternative approach to printing the image. And yet another might spark an idea that relates to another picture altogether. While it is important to work with the known and to limit our choices, say, to just one process, art also works best when the chemistry of the image making process sets it free from the known.

A personal formula

Allan always uses the same two 50ml brown bottles to mix the cyanotype sensitiser, one for solution A, the other solution B: water plus 9.8 grams of ferric ammonium citrate in one, water plus 4.7grams of potassium ferricyanide in the other. These light-proof bottles aren't necessary, as Allan does not store made up sensitiser solutions, but their use constitutes part of a personal formula that includes ritual as one of its vital ingredients.

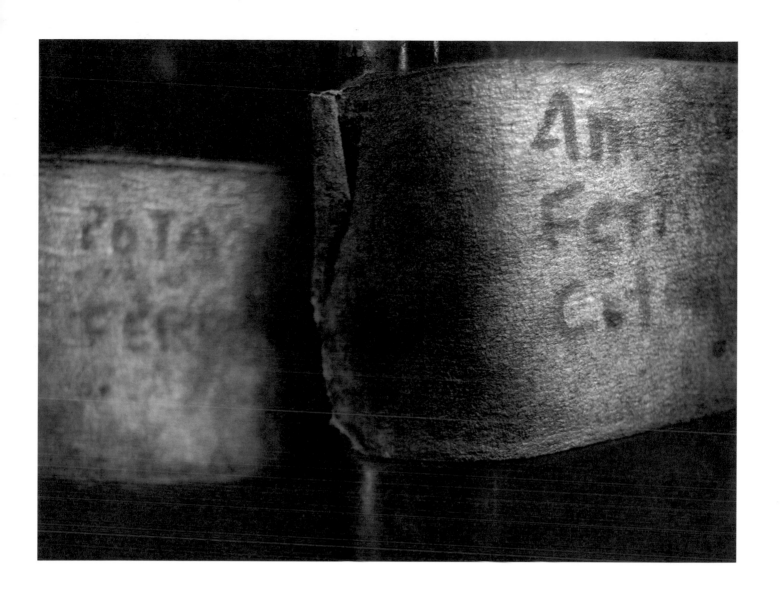

In the beginning, technique is full of hidden mysteries and trial and error. Then we develop our own approach. After a number of years, we can take it to the next level, for example Agfa film, Kodak developer and Bergger paper, to create our own formula. There are choices to make: do I like my images darker or lighter, and how long do I like to tone my prints for? This represents a lot of different formulas coming together to create a personal approach.

Contact printing is the purest form of printmaking.

A handcoated process, returning to photography's roots.

*If we don't know what process to use, we'll never get good results.
At least we should have 100% certainty in the process, even if
we're not sure what kind of images to make.*

*...add the two solutions together in a dish for coating the
paper with a Japanese hake brush. Lift the paper at an
angle, apply chemistry with the brush, then let the solution
flow down the paper...can't stop or it will get streaks.
Then hang up the paper on a line and let excess drip off a
corner...coating large sheets at night, even though working
in the darkroom – just my preferred way of working.*

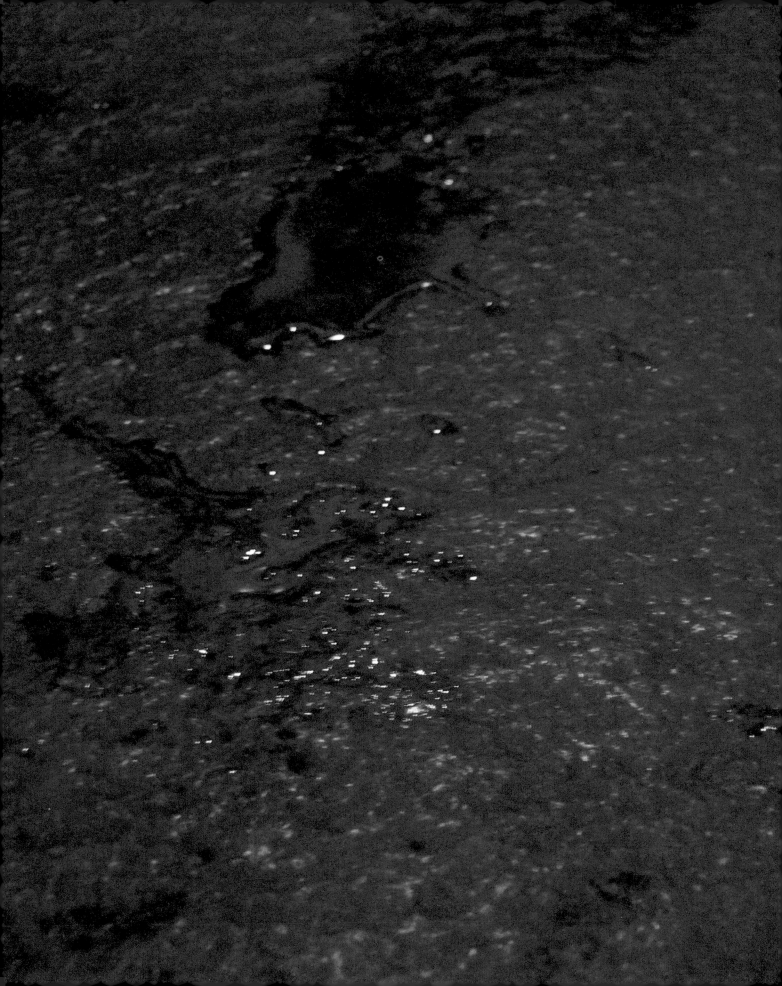

Mood and atmosphere are also created in the printing…warm tones over cool blue cyanotypes. The toner colours the paper as well as the image. In contrast, an untoned print can look very stark with its bright white paper base.

Splash
In the darkroom, Allan experiments and explores effects – playing with the physicality of the hand-coated, toned cyanotype process.

Chemistry and alchemy at work.

As one becomes immersed in a process, one becomes a part of it. Although all my images are made with the cyanotype process, and people might say "same-same", there are subtle differences between every print that makes each unique...variety within limitations. If we have fewer colours to work with, we tend to take the content further than if we have a hundred colour options. When painters couldn't afford expensive colours, they developed pictures in monochromatic browns and greys, and took images to a higher level. Within limitations one can develop a skill a lot more. Reduce the options, just give someone one pencil.

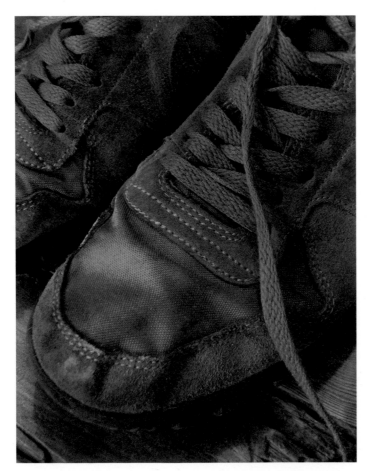

A variable process
The final colour of the cyanotype print is influenced by the nature of the sensitised material. Spilled sensitiser solution on Allan's shoes and on newspaper has printed out under ambient ultraviolet light, each to different effect.

YASOODD M Channon 9-0
ZABEEL HOUSE E Dunlop 9-0
Standard betting — 7-2 Sonny Santino, 6 Marquis
13-2 Yasoodd, 7 Bronzed, 10 Celeritas, Sir Percy, 12
FORM GUIDE: Sonny Santino — 16-1 (9-0) Mid-divi
halfway, ridden over 1f out, stayed on final furlong
Marcus Andronicus (9-0) at York 6f 2yo mdn gd.
out of winning miler Atamana. Racer Forever —
ner Oman Sea. Yasoodd — Inchinor colt, half-brother
Bronzed — Bendolini colt out of a lightly-raced mare
2nd of 8, 1 1/2l behind Puskas (8-11) at Newmarket

KELSO NATIONAL HUNT CARD (Sky Sports 3: 6.35, 7.05 & 7.

Tony Martin	Danny White
6.05 Double Gem	6.05 Chef de Co
6.35 Tribal Dispute	6.35 Escompt
7.05 Bergerac	7.05 Kare
	Prince of Slane
8.05 Sully Shuffles	8.05 Paddy The Piper
8.35 Ballycassidy	8.35 Ballycassidy
9.05 Malt de Vergy	9.05 Malt de Vergy

6.05 QUEENS HEAD "NEW BEDROOMS" MAIDEN HDLE (D) 2m 110yds £10,000 (19 runners)

1	50-0	ANOTHER TAIPAN 21 A Whillans 5-11-2	K Renwick
2	3-	BEAVER 115 R C Guest 6-11-2	—
3	53-3	●DOUBLE GEM 21 J Charlton 6-11-2	P Robson
4	40-3	KING'S PROTECTOR 22 M D Hammond 5-11-2	G Lee
5	304-	LUTEA 27 (BF,D) M Pipe 5-11-2	—
6	0P0/	MINSTER MEADOW 396 S Chadwick 6-11-2	S Gagan (7)
7	000/	NEVER FORGET BOWIE 1063 R Allan 9-11-2	—
8	5	OCOTILLO 6 J Moffatt 5-11-2	—
9	06-6	Alexander 6-11-2	T Greenway (5)
10		JONES M Barnes 5-11-2	J Crowley
11		STRAVONIAN 6-11-2	J Crowley
12		SUMMER SPECIAL Bradburne 5-11-2	M Bradburne
13		THE BOOKEN 12 P Spott 6-11-2	—
		TUSCANY BOY 20	
		AIR OF SUPREMACY Mrs K 4-10-12	R McGrath
		BLUEFIELD Mrs K Walton	N Hannity
		CHEF DE COURS	A Dobbin
			A Dempsey

Standard betting
Beaver, King's Protector, Summer Special, 12 others.
FORM GUIDE:
Double Gem
Apr. Double Gem

6.35 ROYAL HIGHLAND SHOW LADIES' DAY NOV CH (D) 2m 1f £10,000 (9 runners)

1	21-1	TRIBAL DISPUTE 22 (CD2) T Easterby 8-11-10	—
2		MCGRHULE 26	D McGann
3		PHARAOH 21	D McGann
4	0-23	WET LIPS 4 (BF) R C Guest 7-10-12	—
5	-062	WHAT 69 Buchanan (BF) 8-10-12	—
6	PP-P	ALCHEMY 75 M Barnes 5-10-12	—
7			Crowley
8	3-	ESCOMPTE 26 (D)	—
		PEQUENITA	
		AMEBAG	

7.05 FHM DUNN CLASSIC INTERME HURDLE (C) 2m 2f £12,000

1	532-	ALERON 26 (BF) J J Quinn 7-11-8	—
2	11-3	●YES SIR 19 P Bowen 6-11-8	—
3	46-4	ALL STAR 22 N Henderson 5-11-5	—
4	06F-	SPREE VISION 125 P Monteith 9-11-0	—
5	-216	KARELIAN 42 K Ryan 4-11-4	—
6	U5-2	BERGERAC R C Guest 5-11-0	—
7	03-6	WINNER 7 (D) Miss S Forster 7-11-0	—

Standard betting — 6-4 Karelian, 11-4 Yes Sir, 7
Star, Bergerac, 16 Spree Vision, 33 The Ma
FORM GUIDE: Karelian —
6th out
Yes Sir
behind

7.35 M & J BALLANTYNE HANDICA CLASS E D-105 £10,0

1	01-3	WINTER GARDEN 8 (CD) Miss L Russell	—
2	2-1	PRINCE OF SLANE 17 G Swinbank 6-11	—
3	P0-6	CONTRACT SCOTLAND 21 (C) L Lungo	—
4	300-	WILD SPICE 27 Miss V Williams 10-11	—
5	550-	DRUMBO 103 J Buchanan 8-10-12	—
6	3F2	●RED PERK 17 (BF,CD) R C Guest 8	—
7		TA FONGNOW 27	—
8	P1P-	CARNACRACK 47 (BF,CD) Miss S	—

Standard betting — 9-4 Prince of Slane, 5 W
Spice, Red Perk, Contract Scotland, 7 Ta Fa
FORM GUIDE: Prince of Slane
Pran. Winter Garden — 11-4

8.05 ALCAZAR LTD DEVELOPMEN AND BRANDS HANDICAP 2m 110yds £20,000

1	123	PADDY THE PIPER 33 Lungo 8-1	—
2	02-0	●PENNY PICTURES 12 (D) M Pipe 6-	—
3	12P-	JOLLYOLLY 452 P Bowen 6-11-5	—
4	143	SULLY SHUFFLES 34 (CD) M Todhunt	—
5	055-	SCOTS GREY 2 N 7	—
6	PP0	MONDIAL JACK 21 (C) M Pipe 6-10-	—
7	10-F	IT'S DEFINITE 7 P Bowen 6-10-5	—
8	520-	MODEL SON 30 Mrs H Dalton 7-10	—
9		BODFARI SIGNET 7 (CD) S Bradburne	—
10	123-	MINIVET 236 (CD) R Allan 9-10	—
11	0-09	BORDER TALE 8	—
12	02-6	CRYSTAL GIFT 216 A Whillans	—
13	03-3	RIVER ALDER 22 J Quinn 7-9-11	—

A thin negative gives a different type of blue…longer exposures, with denser negatives, create darker, contrastier blues. These tone differently. This explains why print colour varies between different images. I'm not scientific about it.

Process and print

The traditions of photography (and these now include digital) can trap and taint what we do. Yet many of the photographic greats have been inspired by a particular process, worked with it and then made it their own. But that which inspires us can also kill what we do if we fail to make it new. So, how do we avoid the danger of simply repeating the past? What will stop our prints looking like anyone else's, or like something we've done before?

Our chosen process can act as a guide, keeping us on the path, yet it must also remain invisible, acting as a canvas for our pictures and as a frame for our mind's eye to fill. To make a process our own, we need to see as it does, to understand its capabilities and then to work within them, pushing out our own boundaries instead.

The meaning we look for in our photography is beyond what process alone can express, yet it can be accessed through its successful application.

A time to reflect
Part of an old ultraviolet sunbed now used to expose cyanotype prints, which may need up to forty minutes exposure, allowing time for contemplation and re-evaluation of the image.

Attention to detail
A reminder to give extra print exposure to part of the image. *'We can hide a lot of sins with extra exposure, or we can work on the negative itself with old-school Photoshop – a scalpel and Spotone, like the early photographers.'*

The true value of a photograph is not only the image,

but the object itself.

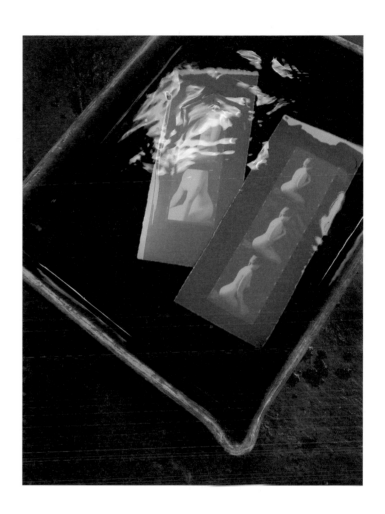

As the print is immersed in water, the unexposed salts are washed out. It starts out as a grey-green-grey image, then light blue...when dry it goes darker blue and when toned the highlights go warm, with the tannin...almost like a filter over the print, giving the picture more depth and warmth. The process isn't as exciting without it. Other methods of toning cyanotypes exists. A quick web search reveals interesting results: thiocarbamide on its own, without bleaching, works...even red wine, but selenium not.

Contact test strips
Allan often uses a 6x7cm camera for experimental shoots, exchanging it for the larger 10x8 format when making a final image.

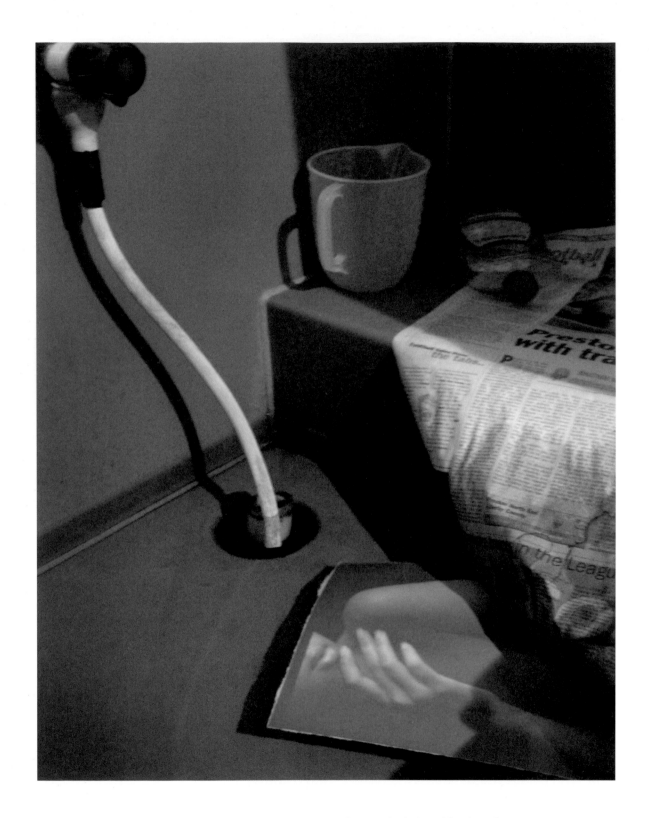

Formulate opinion at the negative stage, then at the light table, then during exposure, then in the sink, then during toning and finally after drying.

Message and content interpreted through size and scale.

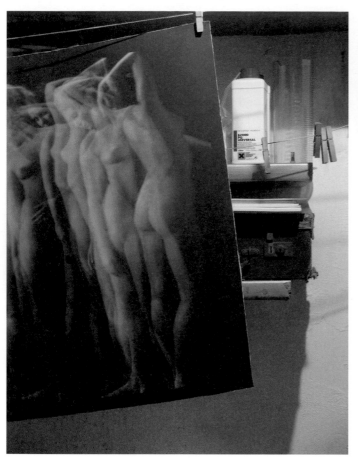 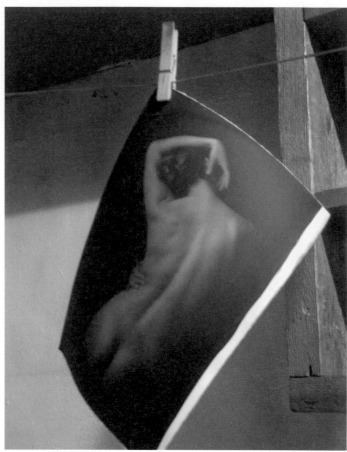

As prints dry, it's a chance to live with the work…I can say, 'I actually made that print.' If we have no idea of what printing is about, how can we be truly connected to our work? Perhaps people don't realise how important it is to be tuned in.

Scale and purpose
Different size contact prints, each chosen for a specific reason: 30x40 for the impact of a multiple exposure image, 10x8 for an intimate figure study and 6x7cm for a test shoot

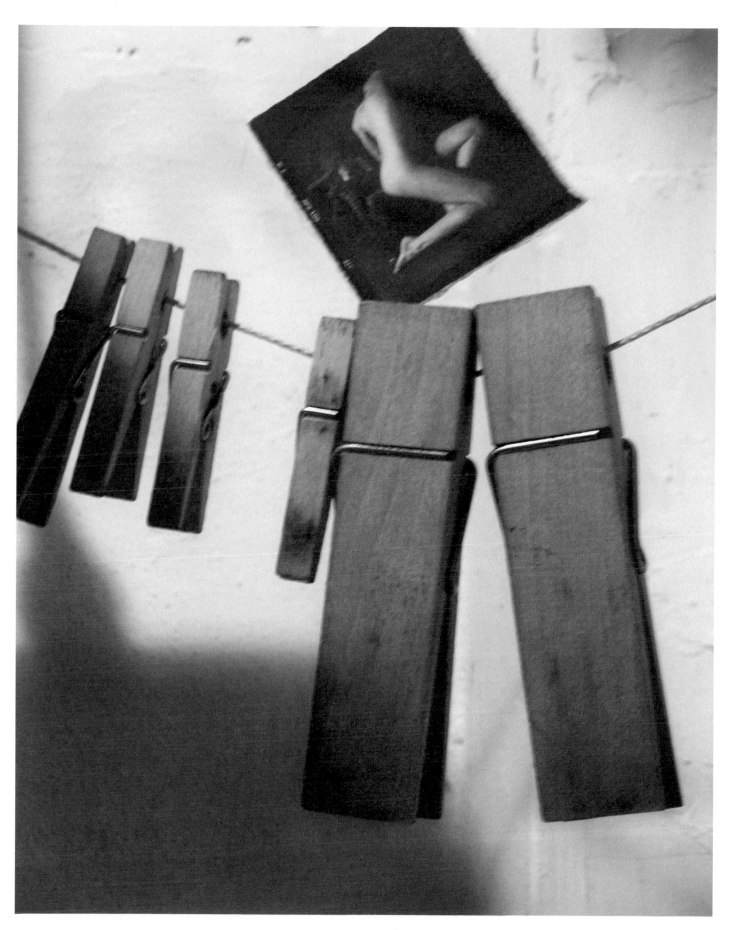

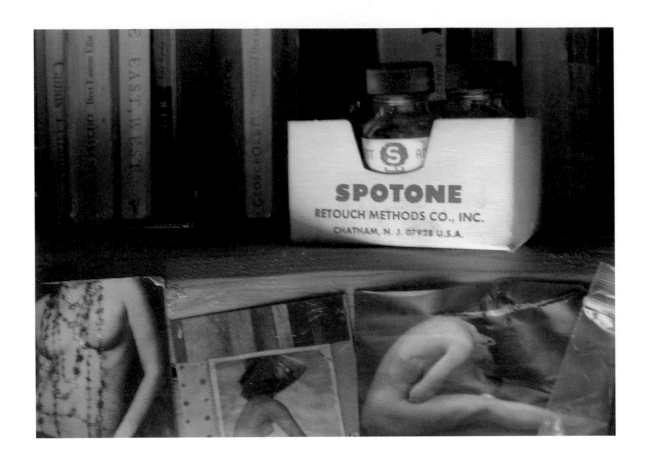

Pressing, retouching, signing, captioning and numbering the photograph, gives the print a hand-made quality, and therefore an intrinsic value, which gives the impression that the worth of the print is as great as the image. Retouching is a final meditation on the print, tuning in to the image. When process comes back to its craft it becomes relaxing, yet requires total focus.

The finishing touches
Spotone and a 000 brush is used to retouch white dust marks on the print. First the loaded brush is drawn across a sheet of absorbent paper to remove excess dye solution.

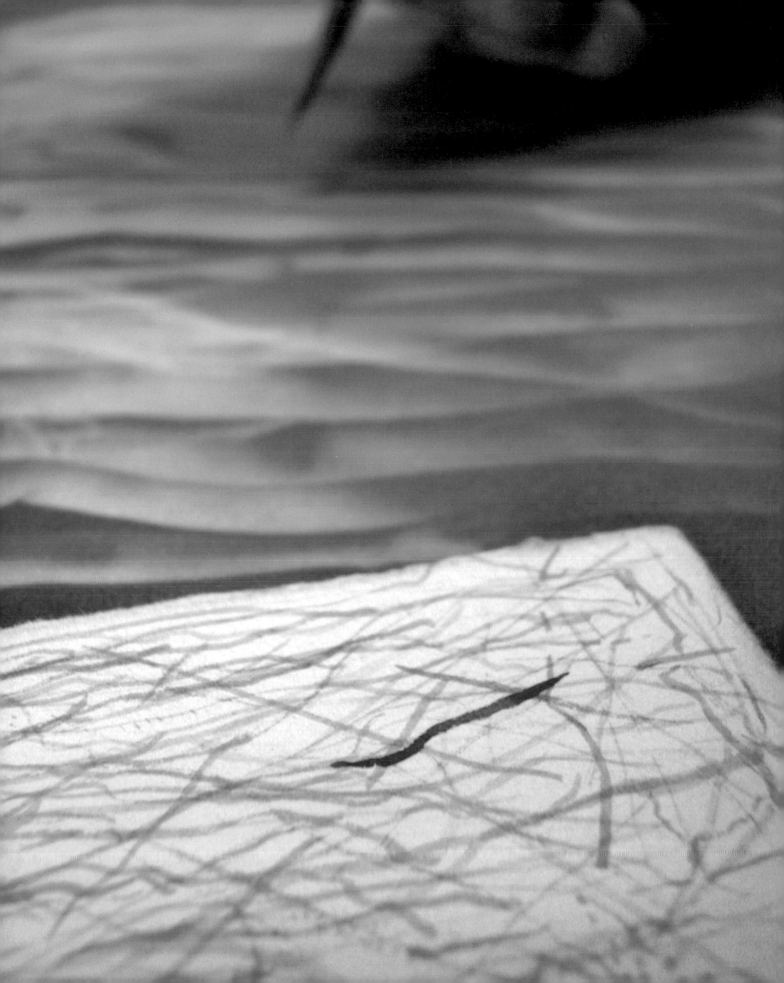

End notes

Usually the subject gives
the best idea of how to
make the photograph

"A Body of One's Own"

"Reclamation" , "revolution" and the recording of these is the essence of what my photographic session with Allan Jenkins was about. What urged such notions was that having had three children in quick succession and they having reached an age of some independence I found / find myself in a new landscape – both physical and metaphysical .

So what was I reclaiming ? My body, my femininity, my sexuality, my individuality, my form. Being photographed was also about recording change, rebirth and altered state. I was thus revolting against or emerging from the period of a woman's life, as a mother, when the body is a machine: "a machine for living in", a machine for feeding from, a machine for offering others comfort and protection. The style of Allan's work allowed for and has recorded, for me, this transition from "functionalism" to "aestheticism". A return to self.

The idea that such change had to be documented was reinforced by the fact that time, youth and state of mind are so fleeting they are often impossible to recapture with memory alone. Allan's work has a resonance of both, that is, documentation imbued with the mood of memory.

How ironic it was then, that the moments of reflection I had during the session focused on the memories of my three daughters birth. They were remembered with a sense of delight, celebration and love, but also with a new emotion of comfortable separateness.

Another contradiction, perhaps, lies in the pun on Virginia Woolfe's title "A Room of One's Own" for to be photographed by a man and later to be viewed by others seems to present anything but "a body of one's own"!! Yet to engage in the activity of being photographed naked was, in fact for me, about being in control of one's choices.

To conclude there was an element of soul mining about this experience to which both sitter and artist / photographer contributed.

'ALLAN JENKINS' TONED CYANOTYPES

Blue is an emotive colour, yet the hectic tones of the raw cyanotype have discouraged its take-up by art photographers over the years despite the archival quality of the process and a generally widespread interest among practitioners and collectors for the older, so-called 'alternative', processes. Jenkins' approach has been to build on the essential qualities of the cyanotype and to mould it, by toning, into something rich, warm and rewarding. His process involves the use of tannic acid to stain the Bergger watercolour paper substrate, rather than the image itself, after the cyanotype is made.

The combination of using only available light in capturing the image, and then his particular take on the ancient process, produces images Jenkins describes as 'dark and mysterious'. The deeper tones in his subject are lifted from the background by shooting against light-absorbent dark velvet; after toning, the raw bright highlights of the original become muted and warm, the shadows rich, lustrous and tactile. Where a raw cyanotype shouts and screams, Jenkins' carefully toned prints murmur and purr.

His choice of still life subjects and models, along with the printing process employed, produce images that could have been made a century or more ago. Indeed, had they been so, then through Jenkins' approach perhaps the cyanotype would have enjoyed a more illustrious existence than it has until now.

The cyanotype is one of the very earliest photographic processes. It was first described by Sir John Herschel just three years after the rivals Louis Daguerre and William Henry Fox Talbot had announced to the world details of their respective and distinctive processes. The Daguerrotype proved popular, but a shortcoming was that by being a 'one-off' process, there was no way of duplicating the image; and no doubt the involvement of mercury fumes in the development process would not have found favour among today's laboratory workers. Conversely, the negative/positive process described by Fox Talbot was to become the basis of photography for more than 150 years. For its part the cyanotype had much to recommend it ? a straightforward, inexpensive process capable of recording fine detail, and tolerant of acid conditions in both the substrate and the atmosphere. However taken overall, and with a few notable exceptions, the strident Prussian blues and cyans of the image have limited its use in pictorial photography. Probably the most famouspictorial application of the cyanotype process was in providing the photogram illustrations of plants and algae for a series of partworks by Anna Atkinson, published just prior to Fox Talbot's 'Pencil of Nature' monograph of 1844. Sadly, the cyanotype's most widespread and ignoble application (exceptions apart) was as a precursor to the architect's humble blueprint. But, on the subject of exceptions, one shining contemporary example is the work of Allan Jenkins.

Chris Dickie
Editor & Publisher, Ag magazine